BACKPACKER

Adventure
Photography

Dan Bailey

D1272676

FALCONGUIDES

GUILFORD, CONNECTICUT
HELENA, MONTANA

An imprint of Rowman & Littlefield

Falcon, FalconGuides, and Outfit Your Mind are registered trademarks of Rowman & Littlefield.

Distributed by NATIONAL BOOK NETWORK

British Library Cataloguing in Publication Information Available
Library of Congress Cataloging-in-Publication Data is available on file.

ISBN 978-1-4930-0974-9 (paperback)
ISBN 978-1-4930-1977-9 (ebook)

∞™ The paper used in this publication meets the minimum requirements of American National Standard for Information Sciences—Permanence of Paper for Printed Library Materials, ANSI/NISO Z39.48-1992.

The author and Globe Pequot assume no liability for accidents happening to, or injuries sustained by, readers who engage in the activities described in this book.

Contents

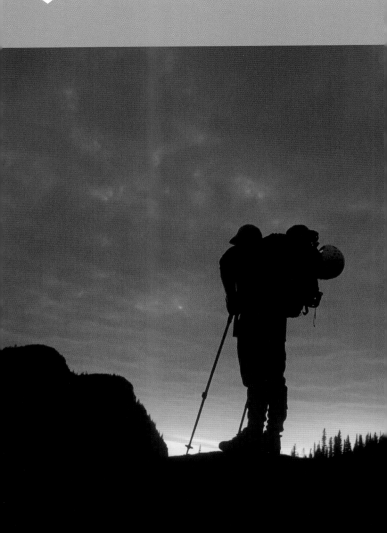

Chapter One

Introduction:
Photography and Adventure

You love to explore with your camera as you travel through the outdoors, always eager to see what's around the next bend. You take special notice when the light turns orange, then pink; when the shadows stretch and you see your fellow adventurers pass by a spectacular background. For you, the photography is often as fulfilling as the adventure itself.

No matter what outdoor activities you like, adventure and photography offer boundless opportunity for creative exploration. Once they get in your blood, these two passions compel you to chase the light and document your travels through the world.

Whether you like to photograph alpine landscapes while backpacking, chronicle the excitement of weekend trips with friends, or capture dramatic adventures, great photography is well within your grasp. You just need to practice and learn a few simple tips to get moving in the right direction. That's where this book comes in.

Written for novice to intermediate photographers, this book will teach you the ins and outs of adventuring with your camera. I'll show you how to choose gear for different styles and activities and how to use it in real-world situations. I'll show you how to carry

your camera and keep it accessible so you don't miss out on great moments. I'll even give you some ideas on how to present your work with maximum impact, whether as prints or on social media.

All of the technical and creative pointers in this book stem from methods I've been using as a pro for nearly twenty years. Yes, you'll find the basics here, but you'll also find valuable tips to help you go beyond mere snapshots so you can make powerful, jaw-dropping adventure images that wow both you and your viewers. In short, this is the photography book I wish I had when I started out.

This is by no means a comprehensive manual on photography; it's a quick reference guide full of essential pointers you can apply to your own style. It's designed to live in your camera bag, backpack, glove box, or wherever you can access it quickly. Take it out onto the trail along with your map and guidebook so you have access to these tips when you need them most. Don't be afraid to get it dirty and dog-eared; I promise you, it won't affect the words.

Photography is a lifelong process. You'll probably get frustrated in the beginning when your shots don't turn out like you'd hoped. However, if you keep at it and shoot regularly, I guarantee that you'll improve, make some great-looking images, and bring your adventures to life long after they're over.

THE POWER OF PHOTOGRAPHY

Compelling photography doesn't just reproduce; it tells stories, evokes emotion, and transports your viewers to places they've never been. To create this kind of lasting effect in your imagery, you must learn how to evaluate light, anticipate moment, and master both the technical and creative aspects of this craft.

Without putting conscious effort into your photography, what you'll get are **snapshots**—casual facsimiles of the world made with little to no technical precision or creative input. Point, click, and you're done.

Snapshots usually don't hold enduring interest with viewers, typically because the pictures focus on content over style: *what* is inside the frame and not *how* it is portrayed. Once your viewers identify the obvious contents of the shot, they move on.

Where snapshots are rooted in *accuracy*, **photographs** are rooted in *ideas* that provoke viewers to imagine the scene for themselves. They don't just copy real life; they abbreviate the world according to your own ideas and creative style. In other words, snapshots give you everything, while photographs give you just enough to make you imagine the rest.

The goal of this book is to help you create images that will both excite you as the artist and remain in the minds of your viewers long after they've turned the page or clicked the next link on your blog.

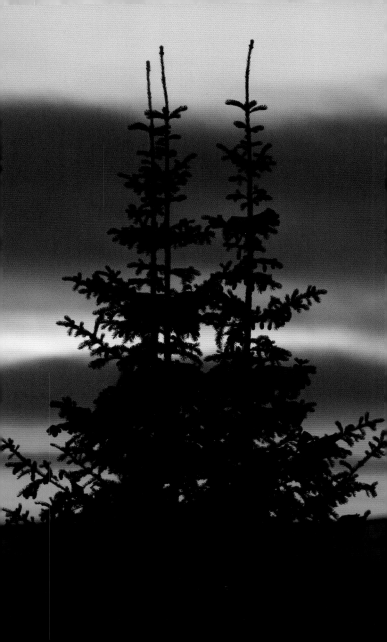

Chapter Two
Digital Photography Primer

Although microprocessors and LCD screens have replaced film, the basic design of the camera hasn't changed in the past hundred years. It's still just a light-tight box comprising three main elements: the viewfinder, the lens, and the sensor.

ELEMENTS OF THE CAMERA

The Viewfinder

The viewfinder transmits light to your eye so you can see what you're shooting. Here are the three types of viewfinders used in modern cameras.

Digital single-lens reflex cameras, or *DSLRs*, use *optical viewfinders*, which reflect light past a retractable mirror in front of the shutter into a glass pentaprism eyepiece.

Prism/mirror systems offer exceptional clarity and a real-time view of the world. When you look through the viewfinder, you see the subject directly through the lens. Due to their precise mechanical construction, optical viewfinders add size, weight, and cost to the camera.

Mirrorless cameras use *electronic viewfinders (EVFs)*, which project the image directly from the

sensor onto a miniature display inside the eyepiece, or onto the LCD screen on the back of the camera.

EVFs give an exact preview of what the sensor will record and they allow you to view scenes with much more detail in low light compared to optical viewfinders. Because EVFs are entirely digital, they don't involve any moving parts or large prisms, which means they're smaller, lighter, and cheaper to manufacture.

However, because the EVF is directly tied to the battery, you won't see anything through the viewfinder if the camera is turned off. Also, EVF quality can vary widely between different cameras.

Some mirrorless cameras use hybrid optical/ EVF systems that offer the best of both worlds.

The Lens

The lens transmits light into the camera and focuses it onto the sensor. Constructed from multiple elements of high-quality ground glass and modern electronics, some lenses are built right onto the front of the camera, while others can be changed out, which is where we get the term *interchangeable-lens cameras.*

Some lenses have a fixed angle of view (*primes*), while some vary in focal length (*zoom lenses*). Built-in lenses offer convenience and reduced size and weight, while larger, interchangeable lenses offer greater flexibility and, oftentimes, increased image quality.

The Sensor

The digital sensor is the image capture device in your camera that translates light into actual photographs. It has replaced film in the digtial world. The sensor is a flat plate covered with millions of light-sensitive photosites, or pixels, and it records the amount of light hitting each pixel after it passes through the lens by converting the variations of visible light into electronic signals.

Sensors are typically differentiated by pixel count, which effectively determines the resolution of the camera. For example, a 12MP camera has 12 million pixels. Generally, the higher the pixel count, the higher the resolution imagery the camera is able to produce. However, that should not be the most important factor to consider when shopping for a camera. Sensor size also plays a role in image quality, because a larger sensor will have either more pixels, and thus produce higher resolution, or larger pixels, which increases the sensor's ability to gather light in dim conditions.

THE CAMERA

Your camera is the main component in your photography system, so you'll want one that offers good picture quality, has a decent selection of creative features, and doesn't weigh you down.

Before you agonize over your choice, though, you should know this: Just about any camera you can buy right now is capable of making great pictures. Don't feel you need to buy the highest-megapixel camera possible, because photography isn't about pixels. It's about light and moment, and how you as a photographer capture those two elements. Those things matter way more than the gear.

In the end, the camera is just a tool. If you pay attention to the complexities of light and composition and learn to be efficient with your gear, you can take great photos with even the most basic camera. A better camera with more features will give you more creative options, but if you don't know the basics, this won't automatically make your photos any better.

Above all, you should get a camera you enjoy using. It should fit your budget and feel good in your hands. The more comfortable and intuitive it is to hold and operate, the more you'll use it, which means the more quickly you'll learn and improve.

DSLRs

DSLR cameras follow the same basic design as the traditional SLR film camera. What distinguishes a DSLR is the large hump over the viewfinder, which houses the pentaprism viewfinder.

Many pro photographers and serious amateurs use DSLR cameras because they have a long track record of reliability. They offer excellent quality, high

The Nikon D5500 is an affordable, lightweight DSLR.

performance and durability, long battery life, a wide array of features, and the largest selection of quality lenses and accessories. Nikon and Canon dominate the DSLR market, but Pentax and Sony also offer a wide selection of full-frame and APS-C sensor DSLR systems as well.

Pros:

» High-quality imagery
» Good performance
» No shutter or viewfinder lag
» The widest range of lenses and accessories
» Excellent battery life
» High durability with premium models

Cons:

» Increased size and weight
» Can't be upgraded

Mirrorless Cameras

First introduced in 2008, mirrorless cameras are becoming the preferred choice for many photographers. With significantly reduced size and weight compared to DSLRs, these systems are ideal for backpackers, hikers, and other outdoor enthusiasts who like to travel with their camera.

Although high-end DSLRs still have a slight edge in performance, the gap is narrowing. In fact, many interchangeable-lens, mirrorless models now produce image quality that rivals, and in some cases exceeds, that of equally priced DSLRs. An increasing number of pros have even switched from DSLRs to mirrorless cameras and have not looked back. I'm one of them, and I couldn't be happier.

While the first mirrorless cameras were built with classic rangefinder-style bodies that lacked the durability for backcountry use, some companies now offer rugged, SLR-inspired designs that are targeted especially to outdoor photographers, especially those who used SLRs in the past. Most high-end mirrorless cameras use interchangeable lenses, but a few models, like the Fuji X100, have built-in fixed focal length lenses.

The main disadvantage of mirrorless cameras is shorter battery life compared to DSLRs. However, that doesn't mean you shouldn't consider a mirrorless camera for outdoor work, because you can always carry extra batteries. I highly recommend having at least one extra, if not more.

The Fujifilm X-T1 is a rugged, weather-sealed, interchangeable-lens, mirrorless camera.

If you're buying your first camera, I strongly recommend that you consider a mirrorless system. Look to Fuji, Sony, Olympus, and Panasonic for the most capable and affordable options.

Pros:

» Compact and lightweight
» Smaller lenses
» Less expensive
» Real-time image preview via the EVF/LCD
» Built-in film-style effects and features

Cons:

» Reduced battery life compared to DSLRs
» Performance can vary widely between models
» Not all models are rugged for extreme outdoor use

Compact Mirrorless Cameras

Today's point-and-shoots are essentially compact mirrorless cameras. While the quality and performance won't compare to a higher-end camera, especially in demanding situations, they're highly portable, which makes them very easy to carry with you on your adventures. They make great "summit cameras."

Many compacts offer built-in zoom lenses and high frame rates for shooting action. Some are even water- and shockproof. Although they have very small sensors, these modern point-and-shoots produce photos that are more than adequate for web and general use.

Having a camera with you when a great moment unfolds is the most important aspect of photography. A beat-up point-and-shoot that fits in your pocket is way better than an expensive camera that's

The Panasonic Lumix LX-7, a capable and popular compact camera.

sitting at home because it's too heavy or delicate to take on your trip. If you want a simple, hassle-free camera that you can shove in your pack or pocket, this may be the way to go. Even if you already have another camera, adding a compact to your kit makes you more versatile.

Pros:

» Size—ultracompact and lightweight
» Highly portable
» Inexpensive

Cons:

» Quality—small sensors
» Lower performance
» Reduced battery life
» Limited accessory choices

CHOOSING A CAMERA

As an outdoor photographer, your camera is going to be a very close companion on all your adventures, so you want to make sure you get one that's intuitive to operate, has the features you want, and fits your outdoor lifestyle.

Be realistic about what you'll be willing to carry. If you pack light, it might be worth trading a little bit of quality for increased portability. No matter how good your camera is, if it's too heavy, too expensive, too fragile, or too confusing to operate in fast-breaking

situations, you'll be less likely to use it. You can't learn to be a better photographer unless you practice all the time.

Do some research and try out a few cameras in the store. You might even consider renting a few models to test. In the end, pick the one that feels like your favorite, and remember—you get what you pay for.

ADVENTURE CAMERAS

Although you can use any camera in the backcountry, some are better suited for shooting action or using in the rugged outdoors. Here are some important factors to consider when shopping for an adventure camera.

Size and Weight

Size and weight are the chief concerns when you're trying to backpack, ski, or climb with your camera. If you want to go ultralight, you'll probably want a compact. If you want higher quality and more performance, go mirrorless or get a lightweight DSLR that's made with high-impact plastic or carbon fiber.

Durability and Weather Sealing

Your camera will take quite a beating in the outdoors. Shoving it in your pack, banging it on rocks,

and subjecting it to extreme elements can drive dust and moisture inside the inner workings and wreak havoc on the electronics. If you're hard on your gear, I recommend getting a weather-sealed camera with metal construction.

I know someone who lost her compact camera on the trail, where it endured 3 months of rain and snow and the teeth of a curious black bear. She later found the camera, dried it out, and recharged the battery, and it still works. Although the camera wasn't weather-sealed, it had an all-metal body, which kept it from being destroyed.

High Frame Rate

While this isn't as important for portraits and travel, a high frame rate is a crucial feature if you shoot sports and adventure. This lets you capture those fluid moments where you often find the most dynamic expressions and body positions.

A rate of 4 to 5 frames per second is adequate for general sports photography, but if you can afford it, get one that shoots at 6 to 8 frames per second; that seems to be the sweet spot for shooting fast action. Unless you shoot *very* fast subjects, such as motor sports or downhill skiing, anything faster than 8 frames per second just adds to your editing workload.

LENSES

Even more than the camera, lenses are the most important tools in your entire photography system. They not only transmit light to the sensor, but they control what the camera sees, which means they are vital in determining what your final pictures will look like. Perspective, angle of view, depth of field, focus, and viewpoint are all based on which lens you use.

Choosing Lenses

Primes versus Zoom

There are two types of lenses, primes (also called fixed lenses) and zoom lenses. Primes only show one view, while zoom lenses are built with movable elements to adjust the view angle and magnification of the lens.

Zoom lenses allow you to vary the framing of your composition without having to change your vantage point. This eliminates the need to carry multiple lenses. Add in the time you save by not having to stop and change lenses when you want different views, and you can see why zooms offer great convenience and tremendous versatility.

There are trade-offs. Zoom lenses are optimized to perform well at all focal lengths, but they're not usually as sharp through the entire range as comparable primes. This is especially true with cheaper

lenses and models with an extremely wide zoom range, such as 18-300mm.

Fast versus Slow

Lens speed refers to its maximum aperture when shooting "wide open." Anything f/2.8 and wider is considered "fast," while lenses in the f/5.6 range and higher are considered "slow."

Fast lenses have larger glass elements that allow them to deliver more light to the sensor. They allow you to shoot at higher shutter speeds without having to increase your ISO setting, which is key when shooting action or when photographing in low light.

In short, faster lenses are always better, but this speed isn't free. Fast lenses are bigger, heavier, and more expensive. However, expensive lenses are usually more durable, and they have advanced electronics, faster autofocus, and special coatings to reduce flare and color aberration.

Buying Lenses

If you can afford it, my advice is to save up and treat yourself to at least one really nice, fast lens; you won't ever regret the purchase. If you're on a budget, it's better to invest your money in decent glass instead of buying a great camera and skimping on the lenses.

Stay away from the bargain bin, and avoid lenses with plastic mounts. Cheap lenses won't withstand the same abuse as high-end glass, they won't be as

sharp, and they may even exhibit distortion and color aberration.

Good-quality glass will produce tack-sharp, high-contrast images with rich color, and it is designed to keep working for years, even after being knocked around, banged on rocks, and sometimes even dropped. Doesn't your photography deserve this?

UV/Haze Filters and Lens Hoods

I recommend using a UV, haze, or skylight filter on your lens. This will help protect the front element of your expensive glass. I also recommend using the dedicated hood designed for your lens. This will protect it even further against hard knocks, and it will also prevent lens flare when shooting toward the sun.

If you keep these two things on your lens all the time, you won't need the lens cap; it's just one more thing to keep track of, and lens caps are more trouble than they're worth. I've seen people miss critical shots because they were still fumbling with the lens cap. Don't let this be you. Trust me—you don't really need your lens cap, not when you're outside shooting.

Chapter Three
Technique in Photography

As with any craft, technique equates to having proficiency with your gear and the necessary skills to solve problems in challenging conditions. In photography it means being able to quickly gauge your scene and pull off a great shot, even with tricky light or fast-breaking subject matter.

The technical aspects of photography intimidate many people, not just beginners. Many longtime shooters still keep their cameras on Auto for every single shot. They're wary of experimenting with different settings for fear of potentially missing a great photo opportunity.

While there's nothing wrong with using Auto mode (I use it quite often), a technically proficient photographer knows when *not* to use it. Although today's cameras are highly capable machines, there are times when you need to compensate for the light or subject matter. Knowing your gear inside out will give you the confidence to take control when things don't go as planned.

Most modern cameras have well over a hundred different settings. However, scrolling through menus during a fast-breaking scene pretty much guarantees a missed shot. If you learn to build an efficient shooting workflow, you'll be able to tackle the problems at hand without even looking.

HOW THE CAMERA SEES

When you press the button on your camera, the shutter opens and temporarily showers the sensor with light coming through the lens. After it closes, the camera's image processor determines the intensity of light that hits each pixel and saves this information to the memory cards as a set of numerical values. Using this data, it also assembles the final image that you see on the LCD screen.

While the sensor can record any amount of light, in order for the photo to look right, you need to deliver a *very specific amount of light* to the corresponding pixels. Otherwise your photo will appear either too dark or too light. Therein lies the essence of exposure.

With that in mind, how do you know how much

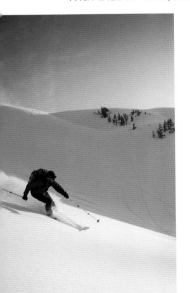

light is required for a good picture? Your camera has a calibrated light meter that tells you exactly how much light you need, and a specific set of tools that lets you control the amount of light hitting the sensor. In addition, the camera has a redundant exposure control system that helps you to capture just the right amount.

EXPOSURE CONTROLS

To understand how this redundant system works, equate light to water and the sensor to an empty bucket, and imagine the three ways you can fill it up: You can send the water through a narrow pipe and let it run for a very long time, you can use a wider pipe and let it run for a very short time, or you can change the size of your bucket. In the end, the result is the same: The bucket is now full of water.

This is how exposure works in photography, but instead of using water, you're filling the photosites on the sensor with a required amount of light. The parameters are the same, though: You can hit them with a small quantity of light over a longer period of time, a larger quantity over a shorter period of time, or change the size of the bucket.

As with your water, the end result is the same no matter which method you choose; the photosites are still full of light. However (pay attention here!), the *overall look of the picture will be radically different* based on how you transfer the water with regard to **time** (shutter speed), **amount** (aperture), and **bucket size** (ISO).

These three parameters are all related. If you change one, you affect the others. For example, if you adjust your shutter speed one way, you must change your aperture or ISO the other way by the same value if you want to retain the same exposure.

In photography these values are called *stops*, and they're based on a system of halves and doubles.

Let's see how these three parameters influence how your picture looks.

SHUTTER SPEED

Shutter speed equates to the function of time, and it controls how long the shutter stays open after you press the button. Shutter speeds on the camera are expressed in fractions of a second. Most cameras have a shutter range of 1/4,000 down to 30 seconds.

Each click of the shutter speed dial gets you half or double the speed next to it on the dial. For example, 1/500 lets in half as much light as 1/250, and going from 1/30 to 1/8 quadruples the amount of light. (Most modern cameras can also be controlled in 1/3-stop settings.)

How Shutter Speed Affects the Picture

Changing shutter speeds alters the amount of sharpness or blur in your image. If you use a very fast shutter speed, say 1/1,000, everything in the frame will be sharp, with crisp edges, frozen water droplets hanging in midair, and moving subjects rendered as if they're forever stuck in time.

Likewise, if you use a very slow shutter speed, such as 1 full second, almost everything in the frame will be blurred. Using medium-length shutter speeds

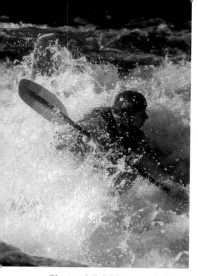

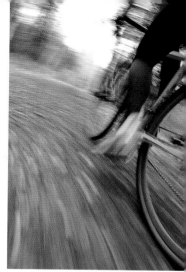

Shot at 1/1,000 second, this photo is tack sharp.

Shot at 1/15 second, this photo has a blurred, in-motion look.

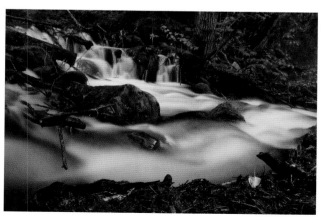

An 8-second exposure turns running water into a soft ethereal flow.

of, say, 1/15 second, will cause a mixture of sharpness and blur throughout the images, depending on the motion of your subject matter in relation to the camera. You should brace the camera or use a tripod when shooting with slow shutter speeds, otherwise you'll end up with unintentional blur in your photo. This is commonly referred to as "camera shake."

APERTURE

The aperture dial adjusts a multibladed diaphragm inside the lens, and it controls how much light enters the camera.

Aperture values on lenses are called *f-stops*, and they're expressed as standard ratios: f/2.8, f/4, f/5.6, f/8, f/11, f/16, f/22. The lowest f-number on your lens represents the widest opening of the aperture diaphragm, while the smallest f-number represents the narrowest opening.

Just like shutter speeds, each full f-stop lets in half or double the amount of light as the previous f-stop. So, changing from f/8 to f/5.6 (one stop) doubles the amount of light passing through the lens.

How Aperture Affects the Picture

Changing the aperture also alters the angle at which the light enters the lens. This affects *depth of field*, or the overall sharpness of your image from front to back. Even though a lens can only focus on one point,

f/4 gives a shallow aperture and an out-of-focus background.

it can show varying degrees of sharpness at different distances within the frame.

Due to the optical characteristics of a lens, a small aperture like f/16 creates a very wide depth of field, just like when you squint. This is ideal for shooting landscapes and scenes that show sharp detail from front to back all the way through the frame.

Use Aperture to Create a Sunstar

If you photograph the sun in a clear blue sky with no clouds or haze, and you use a very small aperture, like f/16 or f/22, you'll get a pronounced "sunstar" in the frame. This happens because the light is diffracted by the aperture blades in your lens, and it can create a powerful element in your composition. The effect is often enhanced if you partially hide the sun behind an object and have it peek out from behind.

A wide aperture, like f/2.8, creates a very shallow depth of field where only a very small plane of subject matter is in focus. Everything in front of or behind that point of sharp focus gradually drops off into a creamy blur, commonly referred to as *bokeh*. This effect is ideal for shooting portraits, close-ups, and scenes where you want the subject to pop against an out-of-focus background.

Because small numbers refer to wide apertures and large numbers refer to small apertures, f-stops and depth of field can be confusing, especially to beginners. Here's a handy tip to keep things straight: *A large f-stop number means that more things will be in focus, while a smaller f-stop number means that fewer things will be in focus.*

Depth of field is also affected by lens type and subject distance to the lens. The wider the lens and the farther away you are from the subject, the greater range of focus you'll attain. Likewise, getting closer or using a telephoto lens results in a shallower depth of field.

ISO

ISO represents the bucket. In camera terms, ISO is a value that controls the sensitivity of your camera's sensor and determines how much light is needed to accurately capture your scene.

ISO comes from the days of film when each type had a different "speed," based on the size of the individual grains of silver halide embedded in the film's emulsion. Slower films, such as Kodachrome 25, required a great deal of light to activate the small crystals, whereas Kodak 200-speed film had larger crystals and required much less light. The trade-off was that faster films had more "grain." They could not produce the same level of sharpness and resolution as slower films.

In effect, it's the same with digital. At higher ISO settings the camera amplifies the electronic signal from the sensor to make up for the reduced light. This process also amplifies the inherent noise in the signal, which shows up in the image.

Although the camera's processor is programmed to remove this noise from the actual image, it's not a perfect system. Higher ISO settings still produce a certain amount of digital noise, although each new generation of camera offers improved noise reduction.

Remember, noise is also affected by sensor size. Larger sensors produce less noise than smaller sensors because they have larger pixels.

What ISO Setting Should You Use?

With a digital camera you can adjust the camera's ISO speed every time you take a new picture. In most cases you'll want to use the lowest setting possible, usually ISO 100 or 200. This will give you the best-quality image with the least amount of noise.

If you're shooting in lower lighting conditions, such as in the forest, at dusk, or inside, or if you need to use a shutter speed that's higher than the current setting allows, you should adjust to a higher ISO. This effectively makes your camera more sensitive to the light. With most modern cameras, you'll find that speeds of 400, 800, and even 1600 can give you very good results. Above that you'll start to see greatly increased noise and reduced sharpness in the details.

There's nothing wrong with having more noise in your photos. It's a subjective trade-off, and in many cases this may be the only way you can pull off the shot. You may just have to live with the increased grain, just like we used to do with film. In fact, with some subjects, more noise and grain can add a very stylized, or "gritty," effect to your imagery.

ISO 200

Very low ISO settings produce crisp photos with fine resolution and very little grain.

ISO 800

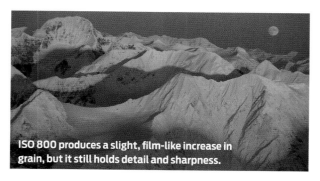

ISO 800 produces a slight, film-like increase in grain, but it still holds detail and sharpness.

Auto ISO

The Auto ISO setting on your camera automatically adjusts the ISO speed so that your shutter speed won't drop below a certain level. In the menu you set a minimum ISO setting, a maximum ISO setting, and a minimum shutter speed. The camera will default to the lowest setting whenever possible, but if the light gets dim and your shutter speed starts to drop, the ISO will increase to keep your shutter speed consistent.

Auto ISO is a very handy setting—it lets you focus on the subject matter and get a sharp image without having to worry about adjusting the ISO each time the light changes. You can always override the setting and change to a new speed, but for general shooting I'd recommend keeping the camera set to Auto ISO.

HOW IT ALL COMES TOGETHER

Photography is all about trade-offs. You can't get something without giving up something else. For example, if you're shooting in dim light, you cannot use a fast shutter speed with a small aperture and a low ISO speed.

If you want a higher shutter speed, you'll either have to use a wider f-stop or a higher ISO speed, or some combination of both. Likewise, if you're

shooting in very bright light and want to show a very shallow depth of field, you'll have to use a very high shutter speed and/or a very low ISO setting.

Understanding how trade-offs work with regard to your exposure controls is the first step toward being a proficient photographer. The next part is understanding how the camera sees the world and responds to the light.

METERING PATTERNS

Your camera has a built-in light meter that evaluates the brightness of your scene. The information it gains is used by the camera's exposure system to recommend the specific camera settings needed to deliver the right amount of light to the sensor and make a properly exposed picture.

However, camera meters only read reflected light. With predominantly bright or dark scenes, such as shooting in snowy conditions or into areas of deep shade, the amount of reflected light from your subject can be very different from the ambient light that's falling on your scene, and this can throw off your meter.

Modern cameras are built with multiple **metering patterns**, each of which is programmed to read the scene differently. While they vary in name across different manufacturers, these patterns fall into three main types. You can use these tools to solve complex lighting problems.

Multipattern Meters

Multipattern meters break the scene up into a number of different zones and evaluate the level of brightness across different parts of the frame. Some cameras also factor in color and distance, based on the location of your selected focus point.

Armed with this information, the camera compares the data against a database of possible exposure algorithms that are preprogrammed into the camera's memory to come up with an ideal exposure.

Multipattern meters are the default meter on most cameras. They're the most accurate type of meter, and in most cases they deliver very good results. I recommend using this type of pattern for most scenes.

Center-Weighted Meters

Center-weighted meters read the average level of brightness in the middle of the frame. They're designed to be most accurate when shooting portraits and close-up subjects like flowers. Center-weighted meters don't work nearly as well with complicated or high-contrast scenes, especially if you compose with subjects that are not in or near the center of the frame.

Spot Meters

Spot meters only read light from the very middle of the viewfinder. With some cameras you can set it to

read the area that corresponds to your selected focus zone.

Spot meters are not very useful for general photography, but they work extremely well if you're shooting a relatively small subject against a mostly dark or light background, say a distant skier in a sea of white snow or a hiker passing in front of a rock wall that's entirely in shadow, or if you're shooting subjects that are backlit.

In these situations the average amount of reflected light doesn't usually match the ambient light falling on your subject, but by using a spot meter, you can isolate and precisely measure a very small area of the frame.

EXPOSURE MODES

Digital cameras contain sophisticated programs called exposure modes that act as the bridge between the light meter and your three main camera controls. Using the current ISO setting and light meter reading, they determine the correct combination of aperture and shutter speed for proper exposure.

With the exception of manual, all of these modes are automatic modes, which means that they do some or all of the work for you. You select which exposure mode to use based on how you want the picture to look and by what level of control you wish to exert in the process.

Program

In program mode, or full auto mode, the camera sets both shutter speed and aperture. In this mode you're relinquishing all control and trusting that the camera will make the right decision. (In most cases it does.) Program mode is great for quick scenes when you don't have time to think about anything but getting the camera to your face in time to grab the moment.

Some cameras allow you to partially override the settings in Program mode. In this mode, also called Flexible Program, you can't alter the exposure, but you can select a different combination of shutter speed and aperture.

Shutter Priority

In shutter priority mode you set the shutter speed based on whether you want to freeze the action or show motion blur in your shot; the camera will automatically compensate and set the correct aperture.

Aperture Priority

Aperture priority mode works just like shutter priority, but in reverse. You set the aperture, and it sets the shutter speed. You use Aperture Priority mode when your primary concern is to control the depth of field in your picture.

Manual

In manual mode you adjust the shutter speed and aperture until the light meter confirms you have enough light for the picture. The exact combination of settings you use will depend on your available light and how you want your image to look.

Using manual mode requires twice as much work as using an auto mode, but it allows you the flexibility to make all the creative decisions yourself. If you're a beginner, I recommend using Manual mode whenever possible so you can gain a solid understanding of how the photography process works.

Special Program Modes

Many cameras have a series of special exposure modes designated for shooting specific types of subjects (sports, landscapes, portraits, and close-ups). In effect, these modes act just like shutter and aperture priority modes. For example, sports mode automatically sets a fast shutter speed, while landscape and portrait modes both set a small aperture for wide depth of field.

Although these modes work just fine, if you're comfortable using shutter priority, aperture priority, and program modes, you can get the same results with fewer choices.

THE HISTOGRAM

Before digital you never knew exactly how the picture would look until you got your film back from the lab. With modern cameras you can check the LCD screen and immediately see your results.

However, LCD screens have limited contrast range, and while they're great for reference, you can't depend on your camera's screen (or the viewfinder) to properly gauge your exposure when you're shooting under tricky light.

That's where the histogram comes in. The histogram is a graph that plots out the brightness level for every single pixel in your image—left side for dark, and right side for bright. It gives you an instant and accurate indication of whether you properly exposed for your scene.

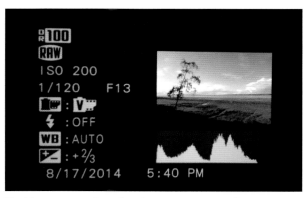

The histogram, as viewed on the camera LCD panel.

Ideally you want your histogram to spread across the entire range of the graph, with no large gaps at either end. If the exposure data extend past the edges, if they are heavily blocked up on one side or the other, or if there are large gaps on either side, this is a likely indication that you're either under- or over-exposing the scene.

If you're shooting very bright or very dark scenes, the graph will lean prominently toward one end or the other. This is okay, as long as it doesn't fall off either end.

You access the histogram in the camera menu, and you can set it to view alongside the JPEG preview after you take the picture. Some cameras let you view the histogram before you take the shot, which indicates how your current camera settings will render the scene.

The histogram is your most accurate tool for gauging exposure, so use it often.

DEALING WITH TRICKY LIGHT

As smart as your camera is, it's not perfect. The light meter is calibrated to give you reasonably good exposure in a wide variety of conditions, from bright sunlight to muted foggy scenes to dim shadows. However, it knows nothing about your own creativity; it only knows numbers.

As I mentioned, cameras are calibrated for reflected light. Overly bright and overly dark scenes can throw off the meter. Also, some scenes have more contrast than the sensor can record. Digital sensors are less sensitive to light than the human visual system, and while the scene might look okay on the screen, it may still fall outside the levels of acceptable exposure.

In some situations you may need to override your camera's automatic exposure settings so that you can get the shot that *you* were hoping for. If you're shooting in manual mode, you can simply adjust either your aperture or your shutter speed and brighten or darken the scene as needed. (Use the histogram to check your results.) In most cases it only takes a stop or two to bring the exposure where it needs to be.

This doesn't work in the automatic modes. If you change aperture or shutter speed, you'll alter the look of your photo, but you won't change the exposure because the camera will compensate. In those cases you can use a different metering pattern, change vantage points, or use the EV+/− control to manually override the camera's auto exposure setting. This is called *exposure compensation*.

Exposure Compensation

To make an EV+/− (exposure value) adjustment, shoot a quick test shot of your scene and either check your histogram or view the image on the LCD

You Can't Show Both Light and Dark at the Same Time

No camera is able to record details in the brightest sunlight and in the darkest shadows at the same time. If you expose for the sunlight, anything in shadow will drop to black, and if you expose for the shadows, you'll blow out the highlights.

When dealing with tricky light, stick to this rule of thumb: *Your main subject should be lit with the brightest light in the scene.* If it's not, you can run into trouble. Here are a three ways to help reduce contrast and ensure you get the best-looking photos when shooting in tricky light.

1. **Shoot in different light:** Wait for the shadows to pass, or come back and shoot the scene during a different time of day, preferably at magic hour. Or simply wait for your subject to emerge from the shadows.

2. **Exclude the highlights:** Recompose your scene and exclude as much of the highlight detail as possible from your frame. You may need to change vantage points or use a different lens.

3. **Let shadows be black:** If you can't get your subject out of the shadows, then expose for your bright background and shoot the scene as a silhouette. This can be a very powerful creative technique; not only will this prevent you from losing the highlights, but you'll create a look based on symbolism instead of details.

screen. If your photo looks too bright or too dark, adjust the EV+/− in the appropriate direction and do another test shot. Repeat and fine-tune until you nail it.

Once you establish proper exposure, you can safely shoot with this new setting, *as long as the ambient light doesn't change.* However, if the sun goes behind a cloud, or if you move into a different lighting environment, then you'll need to do another test shot and possibly readjust your EV+/− setting.

Some cameras allow you to view your EV +/− adjustments in real time inside the EVF or on the LCD panel, which eliminates the need for making test shots. Simply look at the histogram, adjust on the fly, and take the shot. With practice you can learn to make EV adjustments as if they were second nature.

CAMERA EFFICIENCY

Cameras are powerful tools, but they can easily confuse some photographers. The key is learning to be efficient with your gear. Even though your camera might have five or ten different exposure modes, you don't have to use them all. They're included to give you options.

Most of them perform the same function, which is to adjust either shutter speed or aperture, based on how you have the other one set. For example: With

Shutter Priority mode you select a shutter speed and the camera changes the aperture accordingly; with Aperture Priority mode you set the f-stop and it changes the shutter speed. In the end, it's the exact same task, just done with a different control.

I'll explain. When you change the shutter speed in Shutter Priority mode, you'll see the aperture value change in the viewfinder. The same thing happens when you use Aperture Priority mode. In the end, it really doesn't matter which mode or dial you use, because the same numbers pass through the viewfinder and you get the same results.

Remember, you can always override your setting with the EV+/− dial. In a way this is akin to using Manual mode, because you're making an active, manual adjustment to the exposure; you're just letting the camera choose the starting point.

You won't become a better photographer by using all ten modes. In fact, the opposite is true. You'll be more proficient and efficient by *learning how to use one or two modes well.*

Here's my advice: Practice until you can operate the shutter and aperture dials without looking. Then, depending on what you like to shoot, pick a mode and stick with it. If you like to shoot action, choose shutter priority; if you typically shoot landscapes or portraits, choose aperture priority. If you like to shoot a little bit of everything, pick either one and make using that mode second nature. That way, when a great scene is

unfolding, you'll instinctively know which dial to turn and what to look for in the viewfinder.

Technique in photography is all about being simple, fast, and efficient. It's about gauging the scene and knowing how to jump to the appropriate camera settings. Now let's see how to put this into action.

YOUR PRIMARY TECHNICAL CONCERN

For each scene there's a primary technical concern that heavily influences what camera setting you should use.

Let's say you're setting up to shoot an action scene. In this case your main concern is shutter speed. You already know that if you want to freeze a moving subject, you'll need to set it pretty high. If you want to blur the subject and create a wash of motion, you'll need to use a slower speed.

With this in mind, make this parameter *the first thing you adjust.* Before you even compose your scene, spin the shutter dial in the appropriate direction and lock in your desired speed. (If your current ISO doesn't allow you to use the speed you want, simply adjust to a higher setting.) If you prefer using the special program modes, switch to Sports mode before you even put the camera up to your eye.

There. Now that you have the technical work out of the way, you're free to concentrate on the creative aspects of your composition. Either way,

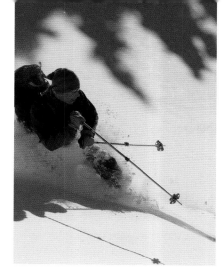

My primary goal was to freeze the subject, so the first thing I did was set a high shutter speed (1/1,250 seconds).

by addressing your primary technical concern and adjusting your shutter speed first, you'll be ready to shoot the moment your subject enters the frame.

Here's another example. You're getting ready to shoot a portrait, and you want to achieve that soft background look. Before you think about light or framing, first set your aperture to a wide f-stop, like

Here I wanted the subject to stand out against a blurred background, so I set an aperture of f/4.5.

f/2.8 or f/4. This locks in your desired depth of field and sets the appropriate shutter speed. Get those things out of the way, and you can now concentrate on capturing a great expression.

What if you feel a wide depth of field would tell the story you're trying to portray? In that case you'll need to stop down the aperture, so do that first. If your shutter speed gets too low when you stop down, then adjust to a higher ISO.

Last example: You're shooting in dim light; that's your primary technical concern. Before you do anything, crank your ISO up a few notches so that you have a better starting point. This will give you more leeway when you start thinking about shutter speed and aperture.

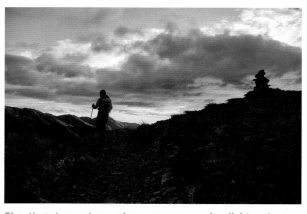

Shooting at sunset, my primary concern was low light, so I set the camera to ISO 800.

AUTOFOCUS

Action and adventure photography would be way more challenging without autofocus. That said, autofocus systems aren't perfect. Even with the best gear, you'll sometimes miss the shot, which can be frustrating. It's important to understand how autofocus works so you can learn how to make the most of it in difficult situations.

How Autofocus Works

Autofocus (AF) systems evaluate slight changes in contrast within the frame while a motor inside the lens adjusts the glass elements back and forth. When the highest level of contrast has been detected on the sensor, the camera's AF processor tells the lens to stop moving and signals with a beep that the subject is in focus.

AF performance is directly tied to two things: cost and light. More expensive cameras and lenses contain more advanced AF modules and faster motors. In addition, faster lenses with brighter maximum apertures deliver more light to the AF sensor. The more light you have, the better the system will perform.

You'll find that autofocus performs poorly in the dark. Dim light makes it hard for the AF sensors to detect contrast, so the lens hunts back and forth, which wears down the battery. Most cameras have an AF-assist beam, but these have limited range, so they don't work very well outside.

How to Use Autofocus with Moving Subjects

Most AF systems won't give you any trouble with still subjects. However, moving subjects can present certain challenges. Here are some ways you can stack the deck in your favor and get the most from your camera. (Refer to your manual to see the specific functionality of your camera's AF system.)

Select Your AF Mode

» **AF-S:** In AF-S mode, also known as *single servo*, *focus priority*, or *one-shot* mode, the camera won't release the shutter until the subject is in focus. This mode is for shooting still subjects. However, nothing says you can't shoot moving subjects in AF-S mode, and in fact, if you're just going for a single shot of the action, you might actually prefer to use this mode.

» **AF-C:** In AF-C mode, also known as *continuous servo*, *release priority*, or *AI servo* mode, the lens will keep adjusting focus even if the subject moves, and it will keep focusing across multiple frames. As long as you press the shutter, the camera will fire, whether your subject is in focus or not. Keep in mind that if the AF system doesn't lock on before you press the shutter, you may end up with an entire series of out-of-focus shots. Nonetheless, this is the mode to use for shooting a series of action photos.

Select Your AF Point—or Let the Camera Decide

Next you'll want to select the AF point or zone that matches where your subject is in the frame, or where you think it will enter the frame. If you get close before the action starts, your lens won't have to go looking for the right subject. On most cameras, you select the focus point via the thumb pad.

You can also let the camera choose the focus area. In full-auto mode, cameras are programmed to lock onto whatever is closest to the camera. However, this may not be where your subject is, and sometimes you can end up with the wrong thing in focus.

With moving subjects, select Continuous AF-C.

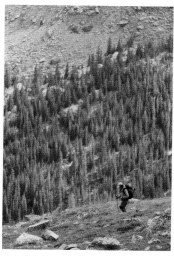

This hiker was moving slowly enough that I was able to select the focus point manually.

When the action starts, tweak your composition so that your subject falls right in line with your chosen AF area. Even if it's not quite the framing you were looking for, once you have the subject locked, you can readjust to your desired framing.

Prefocus on Your Subject

Sometimes you'll face situations or equipment limitations when your AF system cannot keep up with the subject. During those times you can try setting the camera to manual focus and then prefocusing on the precise location where you think your subject will be. As soon as it reaches the location, you press the shutter and hope you nailed it. When all else fails, you'd be surprised at how well this can work. You can increase your odds for success by shooting a quick burst in Continuous mode.

You'll find most adventure activities to be quite predictable with regard to motion, especially if you have a working knowledge of the activity. With scenes that aren't very predictable, or when shooting erratically moving subjects, your alternatives are to use a very wide depth of field or focus on another prominent element and let the subject go a little out of focus. When all else fails, switch to Burst mode and go with the "spray and pray" technique.

With enough practice all of these techniques will become second nature. Learn your gear, use it often, and you'll become a proficient technical photographer.

Chapter Four
The Quality of Light

Regardless of your experience or equipment, you operate with the same light source as every other outdoor photographer in the world: the sun.

However, as you've probably noticed, sunlight doesn't always look the same. Changes in geography, latitude, humidity, weather, season, and, of course, time of day cause infinite variations of the sun's rays with regard to intensity, brightness, direction, and hue. The sun looks vastly different at midday than it does at sunset, under a cloudy sky, or just after a rainfall.

In many ways light fuels photography, even more than the subject matter itself. Just like your eye, the camera sensor doesn't "see" the subject; it simply measures the intensity and color of the light being reflected back from the subject into the lens.

Imagine two photos of the same subject shot from the same vantage point during different times of day. They won't look exactly the same, because the quality and direction of the light will be different. Now imagine that one of those photos was shot under what you might call "ordinary" light, while the other was shot under remarkable light that bathes the subject in a mix of rich colors and dramatic shadows. Which photo do you think will have more impact?

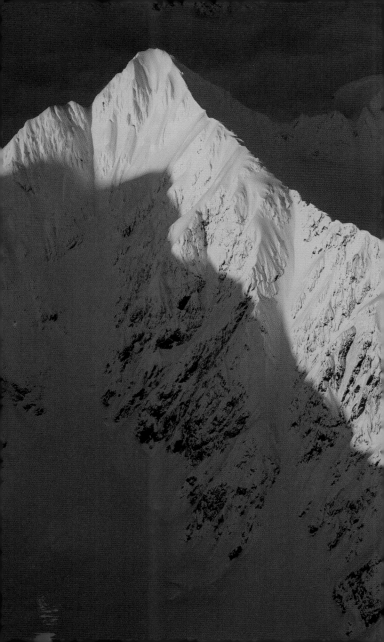

Creative photography isn't just about shooting things, people, and activities; it's about chasing good light and capturing your subjects in the most appealing, unique, and stunning light possible. How you use the light determines the overall look and quality of your photos. Therein lie the challenge and the unexpected rewards of outdoor photography.

Although it takes years of practice to become a master light wrangler, you should understand the three basic qualities of light and how they can affect your imagery.

» **Color:** As the hours change each day, the hue of sunlight can vary from the coolest blue to the warmest red and every imaginable color in between. The color quality of your light depends largely on time of day and whether you're shooting in direct sunlight, in shadowed light, or under cloudy skies.

» **Direction:** Is the sun directly overhead, or is it low on the horizon? Is the light in front of your subject, behind it, or streaming in from the side? Direction plays a big part in photography, because it affects the visual "depth" of your subject matter and determines how your shadows look.

» **Intensity:** Direct, full sunlight is hard and intense, while light that's diffused by clouds or partially blocked by some object tends to be softer. Neither is necessarily better or worse

for photography. As you'll see in this chapter, which one you use depends largely on what you're shooting.

Now let's explore some of the different kinds of light you'll encounter when shooting in the outdoors. Note that many of the image examples I've included use more than one creative technique or compositional method. As you look through the book, study each photo and try to identify all of the techniques that apply, aside from the concept being mentioned.

COLOR

You've probably learned that some of the best times for photography in the outdoors occur during sunrise and sunset, also known as *magic hour*.

When the sun is close to the horizon relative to your vantage point, its rays pass through more of the atmosphere as they skim across the edge of the earth. Dust, moisture, and haze in the air scatter out the shorter wavelengths of blue light much more than the longer wavelengths of red and orange.

By the time the light from a setting or rising sun reaches you, most of the blue light has been removed, leaving only the warmer hues of red, orange, and yellow light to shine on the scene. In addition, shadows grow richer in color and elongate to exaggerated proportions.

It's hardly an exact science. The sun draws a slightly different path across the sky each day of the year, and the arrangement of clouds in the sky is never the same from day to day. You never know exactly how the light from a setting sun will look on your subjects until those magical, ephemeral moments come to pass.

No two sunsets (or sunrises) are identical. Sometimes you'll be treated to incredibly bold light with rich colors and strong contrast, while other

A similar scene shot under very different light.

times a band of clouds at the horizon will leave you with only slightly muted colors and dim shadows under the softly fading light. This is the true adventure of photography.

Outdoor photographers practically live for magic hour, and so should you. Nearly every single subject looks better with rich warm light and pronounced shadows, which is why you should seek it out and use it whenever possible. Where photos taken at midday tend to make subjects look "ordinary," the same subjects shot at sunset will make for dramatic, striking photographs that jump right out at the viewer.

Chase good light, make the effort to put yourself into situations where you think it will appear, and I guarantee that you'll make better photographs.

The Best Light

With a clear sky, the rich light hues of magic hour begin to appear about 1 to 2 hours before the sun hits the horizon. Varying factors, such as latitude and the amount of dust, pollution, and moisture in the air, will all affect the exact quality of light that's cast upon the scene.

In addition, any clouds present will also be lit by the warming light, which can add another dynamic element to your scene. Just as the sunset light makes your subjects appear more brilliant, the clouds will continue to become more brilliant as the sun goes down.

Latitude Affects Magic Hour

The sun's path across the sky varies at different latitudes. Close to the equator the sun travels a nearly vertical path up and down across the sky, which makes for a relatively brief magic hour. Farther north (and south) from the equator, the angle of the sun's path lessens, which increases the length of time when the sun appears close to the horizon. In effect, this extends the length of magic hour.

In extreme latitudes, in places like Alaska, Scandinavia, and northern Canada, the sun travels in a very shallow trajectory across the sky, which can cause the warm light of sunrise and sunset to last for a few hours. In the middle of winter, the sun doesn't rise more than a few degrees above the horizon during the entire day. Depending on the weather, golden and pink light can last as long as the sun is up.

Although it may seem like a crazy idea to travel to places like Alaska and Norway in the wintertime, this is actually an amazing setting for photography. If you can brave the clear, cold air of January and February, you'll typically be treated to many days of beautiful light that you won't get to see anywhere else in the world.

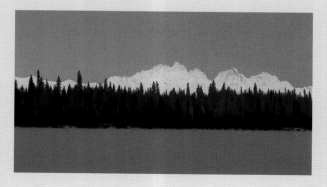

Blue Hour

Blue hour, otherwise known as twilight, occurs for about 40 minutes in the morning and evening, when the sun is entirely below the horizon. During this time there is still a fair amount of indirect light present, but all of the red wavelengths of light from the sun pass directly into space, leaving only the short, scattered beams of blue light to reach the earth's surface.

The result is that the entire scene is lit with a muted palette of deep blue hues that tend to mimic the quiet patterns of nature. Blue hour is a wonderful time to photograph, especially if you can include the contrasting warmth of campfires, flashlights, electronic flash, or urban lights. Alpenglow typically appears at blue hour, and it's also the ideal time to photograph the full moon rising or setting above the landscape.

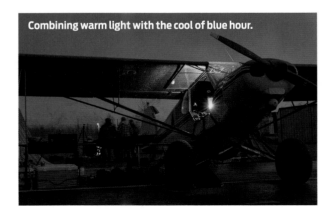

Combining warm light with the cool of blue hour.

Light Painting

Blue hour is also a great time to experiment with light painting. Put the camera on a tripod, shoot with a very long exposure (around 30 seconds), and "paint" part of your scene with a flashlight or the white screen of a mobile phone. (You can also just wave the light around in front of the camera.) This creates a fun effect with long, continuous light streaks throughout the frame.

Be creative. Try painting a particular feature in the landscape, shine a flashlight inside a tent, draw pictures, or even try writing your name with the light.

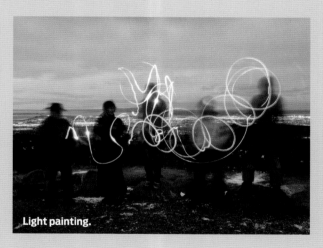

Light painting.

Don't put away your camera after the sun goes down.

DIRECTION

The classic rule for beginning photographers says, "Always keep the sun at your back." This puts your subjects (people) in direct sunlight, which keeps shadows off their faces and makes it so they don't have to squint. While it's good to avoid dark faces, especially when shooting portraits, if you stick to this adage all the time, you'll miss out on one of the key factors that light plays in photography: direction.

The direction that light travels from its source (usually the sun) to your subject determines the quality of your shadows. Shadows are a vital element in photography because they accentuate shape and texture and block the light from hitting certain parts of your subject.

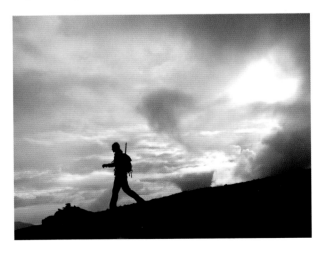

Partially obscured subjects create an air of mystery and wonder in your viewers' minds. Shadows represent the unknown, and this characteristic translates into photography. Oftentimes what's hidden in the photo plays as much a part as what's visible. Your viewer doesn't need to see everything, and by paying attention to the direction of the light, you can accentuate the depth and mood of your photographs.

Overhead Light

The middle of the day can be a tricky time for outdoor photography. Overhead sunlight casts strong, direct light where shadows become almost nonexistent. This is the least dramatic type of light in photography, and it's often harsh and unflattering, especially for portraits and close-up subjects.

However, broad daylight can work for expansive scenes with a lot of color, because it renders your subject with even illumination and minimal shadows. Think fields of wildflowers or people out adventuring in the world.

Midday light will lack the kind of interesting depth you'll get if you shoot when the sun is lower in the sky. With that in mind, it's an ideal time to scout for new locations and shoot reference photos for places that you might revisit at magic hour.

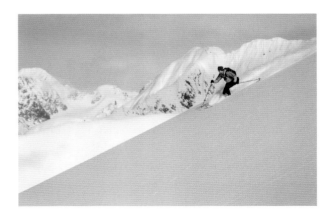

Sidelighting

Sidelight creates pronounced shadows and adds depth to your photos, which make it ideal for creating complex and dynamic portraits. It also works great when shooting landscapes. In fact, just about any kind of subject looks more interesting with sidelight, so you should use it often in your photography.

Sidelight doesn't have to be 90 degrees off axis to work. Experiment with different vantage points

and notice how varying angles of light affect the look and mood of your subject matter.

The most dramatic sidelight occurs during magic hour on clear days when the sun is very close to the horizon.

Backlighting

If you go to the extreme with sidelighting and place the subject directly between you and the sun, you have backlighting.

With backlighting you're technically looking into the shadows, an effect that creates soft, even illumination on your subjects. If you're close enough, you'll create a "halo" of sunshine around the edge of the subject, which adds to the drama of the photo. Another advantage of photographing people with backlight is that they won't be forced to squint.

Backlighting can be tricky to use, because you'll often be dealing with a high degree of contrast between the subject, ambient light, and background. Backlighting works best when you shoot against a shaded background, such as a broad mountainside. If you place your subject against an open sky or use a background that's lit with direct sunlight, your contrast ratio will likely end up being too wide for a good exposure.

When you're shooting backlit subjects, especially at midday, you may find that using longer lenses can help control your background. Backlighting

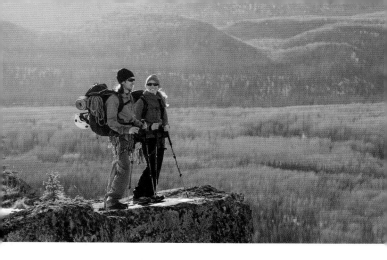

with wide-angle lenses in broad daylight rarely yields appealing results. However, as magic hour approaches, your creative options open back up with regard to lens choice.

Backlighting is extremely effective for shooting portraits at the end of the day, and it works with any type of lens. Place the low sun almost directly behind your subject and expose for their face, and you'll give them a rich halo of golden light and create a nice, warm background. You may end up with some overexposed highlights in the sky, but with a great image, this will be overshadowed by the overall character of the scene.

Silhouettes

Another way to use backlighting is to create silhouettes. Instead of shooting up close, back up, focus on the greater scene, and set your exposure for the

background. Your main subject will fall into shadow against the brightly lit sky. Keep in mind that this technique will only work with a deep blue sky or if you're shooting at sunset. If it's cloudy, you'll have to use a different approach.

Although natural elements in the landscape work as silhouettes, the most common way to shoot a silhouette is to place human figures in front of a

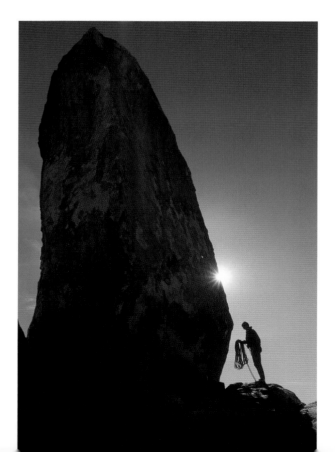

dramatic, highly saturated sunset sky. The more strik-ing color you have in the sky, the more dramatic your silhouette will be.

You can increase the power of your silhouette by placing the sun directly behind the subject so that part of it "peeks" out around the edge. Stop down to f/16 or f/22, and you'll create a "sunstar." You might need to do a few test shots and fine-tune your cam-era settings to get the perfect exposure for your sil-houette. Also, make sure the flash is turned off, or you'll ruin the effect.

Silhouettes work so well because they prompt viewers to imagine themselves in the scene. Although the subjects are not always recognizable, by suggest-ing the setting or activity the subject is engaged in, you can create a powerful visual narrative. You don't actually need to show every single detail to tell the story. Sometimes the less you show, the more power-ful your image will be.

Spotlighting

As with stage performance, spotlighting occurs when a single beam of sunlight hits your subject, either through a break in the clouds or through an opening in the terrain that partially blocks light from hitting the rest of the scene. The effect is that your subject is the only thing lit against a shadowed background.

Spotlighting is one of the most dramatic types of light you can use in photography. You'll see it right

before the sun dips behind mountain ridges, inside forests, under the light of clearing storms, and during times when the sun is low in the sky. You can even create spotlighting with a flash.

INTENSITY

Overcast Skies

While it's not always the best light for shooting broad scenes, there are plenty of great photo opportunities to be had when the sun disappears behind the clouds.

Clouds and fog act like giant studio softboxes for the sun, and they create diffuse light that gives a much softer look in photographs. Soft, overcast light allows you to capture a wide range of tones, details, and colors without any glare or harsh shadows, and it's perfect for capturing scenes that would be problematic under direct sunlight and clear skies, such as when shooting inside thick forests.

Cloudy days are also the perfect time to move down to the macro level and shoot the details of nature. Soft light lets you accentuate the delicate colors and gentle textures of wildflowers and other foliage, and it's the perfect light for shooting long-exposure motion blur photos of streams, rivers, and waterfalls.

Landscapes can look great under cloudy skies, as long as you minimize the amount of white sky in

Shooting close-up under overcast skies reduces contrast and makes colors pop.

your frame. At the same time, large areas of fog that transition into your scene can add a very serene and mysterious quality to your photographs.

Overcast skies are also the ideal light for shooting portraits. With contrast levels brought to a minimum, you won't have to deal with shadowed faces and overexposed backgrounds, and your subjects won't be squinting. As with landscapes, be sure to move in close and eliminate as much sky from your frame as possible.

Rain and Storms

Everything I just said about soft light applies when it's raining, with one huge plus. Storms look awesome in

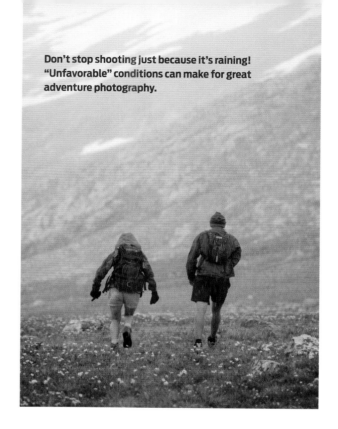

Don't stop shooting just because it's raining! "Unfavorable" conditions can make for great adventure photography.

photographs. Whether you're shooting landscapes under threat of ominous storm clouds or adventurers braving the elements and enduring bouts of wind and rain, storms add great intensity and excitement to your outdoor imagery. (See Chapter 7 for tips on how to protect your gear while shooting in bad weather.)

Another benefit to shooting in the rain is that wet surfaces cause colors to appear highly saturated,

The Blue Light of Shade

Dark, underexposed shadows take on a rich black appearance in photographs. However, when you're actually shooting into the shadows or photographing under direct shade, the indirect light shows a distinct, cool blue cast in your imagery.

Due to the way our brains compensate for color temperature, you may not recognize this color shift, but it will be apparent in your photos. To combat this, you can use a slight 81A warming filter on your lens that will counter the blue cast.

If you shoot in RAW, you can also adjust the white balance inside your processing software to warm up the image slightly. (This is my preferred method.) Take note: This technique won't be as accurate if you're shooting straight JPEGs. If you like to shoot in JPEG, you're better off getting a warming filter.

which makes the hues of your scene pop even more. Also, some of the most dramatic light in nature occurs at the tail end of storms. During these times you often have rays of afternoon sunlight shining through distant virga, lighting up the landscape beneath the retreating cloud banks, or creating rainbows . . . all the more reason to get outside with your camera even when it's not sunny out.

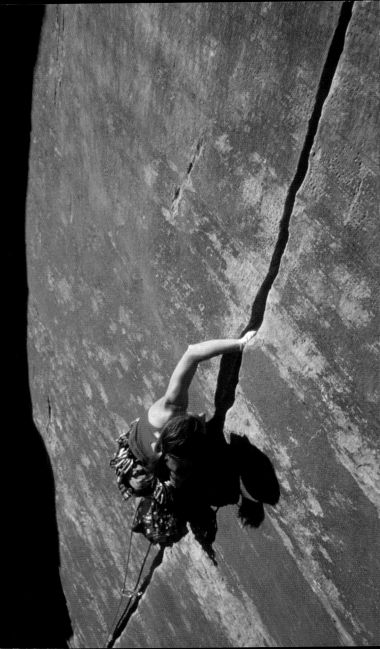

Chapter Five

Creativity and Composition

Each person has unique ideas about the world, and these ideas are reflected in his or her artistry. Two people with identical cameras and lenses can photograph the exact same subject and produce two completely different images. Although they might possess similar technical skills, ultimately it's each person's creativity and sense of composition that sets their imagery apart.

In simple terms, composition in photography can be defined as *what you include in frame, and where you put it.* In this chapter I'll present some basic compositional methods for arranging subject matter and building your photographs. Practice these techniques whenever possible and incorporate them into your style.

INGREDIENTS FOR A GREAT IMAGE

I like to think a great photograph is built from three essential ingredients. No matter what kind of subject matter you're shooting, incorporating these three elements in your compositions will elevate your imagery above mere snapshots.

» **Light:** Dramatic light makes for dramatic photos. Subjects shot in great light will always be more interesting than those shot in average

light. Seek out and wait for good light, and you'll watch the quality of your photographs improve from day one.

» **Moment:** Also known as the "decisive moment," this is that brief second or split second that occurs at the height of the action, when the light peaks with the most brilliant colors, or when your subject portrays the most interesting expression or body position within a set time frame. Keep your eyes open and keep your finger on the shutter.

» **Convergence:** Great photos happen when great light, powerful subject matter, and a compelling background converge. That's when you want to press the shutter. Pay close attention to your surroundings, learn to anticipate when elements might converge, and then put yourself in the best position to capture it.

BASIC PICTURE-TAKING WORKFLOW

Photography is a fluid activity. Depending on your environment, shooting style, and subject matter, it can vary wildly in execution—especially outside.

If you were to study how different photographers approach the same scene, you might not think there is an established process to follow. One person might shoot in a very calculated and controlled style, while another might make the process look highly chaotic

and reactionary. No matter how they work, all photographers go through the same basic mental checklist before pressing the shutter.

Regardless of the situation, there is a similar set of steps everyone follows, even if they're not consciously thinking about them at the time. If we break the process down from start to finish, there are six essential steps.

1. **Look for a subject:** As you move through the world, look for interesting subject matter or intriguing light. Pay attention to not just what's happening around you but what *could* happen if circumstances occur in a certain way, even if you were to direct how the scene plays out.

2. **Look for secondary elements:** If a compelling subject catches your attention, keep your eyes peeled for additional things in the scene that you could use to play off of the main subject, such as striking backgrounds, good light, or secondary subject elements.

3. **Decide what story you want to tell:** How do you want to portray your subject matter? Think about the specific ideas or concepts you'd like to convey with your imagery. Arrange all of the elements in your image and build the shot. Move around and look for an ideal vantage point.

4. **Establish technical limitations and creative ideas:** Nail down your primary technical concern and figure out how to overcome any limitations or technical complications your scene might present. Decide how you'll expose for the shot and set your camera controls as necessary.

5. **Choose lens/focal length:** Decide which lens or focal length will match the way you see the scene in your mind. If you're unsure, experiment, but be quick and practical. Don't waste time, or you'll miss the moment.

6. **Create the final composition:** Nail down your final framing scheme. Wait for the exact right moment and press the shutter precisely when your subject passes in front of the background or when the light hits your scene in the right way. Be ready to adapt to any changes that might occur.

It's okay if you don't stick to this exact order. Maybe you prefer to choose your focal length earlier in the process or take care of your technical concerns before figuring out the exact story you'd like to tell. In fact, you don't have to stick to this list at all. As you become more proficient with your photography, you'll develop your own workflow.

CHOOSING A LENS

Whereas your eye has only one focal length, camera lenses are built with a wide range of focal lengths. (Zoom lenses have adjustable focal lengths.)

Lens focal lengths can be described as *wide angle*, *normal*, or *telephoto*. You impart the characteristics of the type of lens you choose into your composition. Let's explore how you can use each type in your photography.

Wide-Angle Lenses

Lenses with a relatively short focal length are considered wide angle. These lenses show a very broad view of the scene by expanding perspective and exaggerating the distance between objects in the frame. This imparts a very three-dimensional look to your imagery, and it allows for a greater depth of field than you would normally be able to get with other lens types.

Wide-angle lenses let you create images with tremendous visual depth that are sharp from front to back. By shooting close, you can capture an intimate view of your subject and still show the subject in context with its environment. This technique works great for shooting dynamic landscapes and also for shooting sports and adventure from a vantage point that brings the viewer right into the middle of the action.

Wide-angle lenses demagnify the scene, and thus are less prone to camera shake. This means you

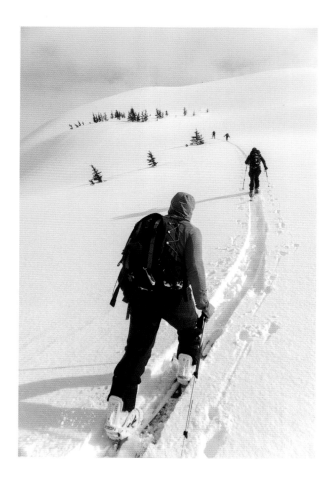

can hand-hold them at lower shutter speeds. This makes them useful for shooting in low-light conditions. For general outdoor photography wide-angle lenses offer tremendous versatility and lots of creative options.

Wide-Angle Lens Techniques

>> Landscapes
>> Candid shots, and shooting from the hip
>> Environmental portraits
>> "Middle of the action"
>> Low light and inside

Fisheye Lenses

Fisheye lenses are specialized, ultra-wide-angle lenses that show extreme angles of view, usually up to 180 degrees. They do this by dramatically distorting the image, making it appear as if you were looking at the scene through a drop of water. Fisheye lenses aren't very practical for general photography, but they can be used to create a fun special effect.

Normal Lenses

Normal lenses are called "normal" because they show a viewpoint and spatial perspective very close to that of human vision. This makes them the ideal lens to use when you want to portray the scene just as you saw it with your own eyes.

Normal lenses have very limited depth of field when shooting at close and medium distances, so they're great for shooting portraits, showing details, and isolating a few elements in the landscape. However, they're not great for action and sports, especially at longer distances, because everything ends up being in focus.

Normal lenses typically make great "first lenses" for novice photographers. When you're trying to learn how the camera works, and at the same time training your brain to "see," it often helps to begin with a familiar viewpoint instead of bringing a variety of lens types into the mix.

Normal Lens Techniques

» Showing the scene as you see it
» Portraits
» Isolating relatively close subjects

Telephoto Lenses

Telephoto, or long, lenses bring the faraway world up close by showing a narrow view of the scene and magnifying subject matter in the frame. They have the opposite optical effect of wide-angle lenses;

telephotos compress the perspective and portray the scene with a more two-dimensional look and a very shallow depth of field.

Telephoto lenses let you isolate your subjects in crisp focus against a blurred background. In addition, the size and distance of the background are magnified in relation to your subject. This lets you create larger-than-life backdrops that loom behind the subject. With longer focal lengths these visual effects will be exaggerated even more.

Instead of using a plain background behind your subject, it often helps to include one or two additional elements in the frame, either behind or in front of your main subjects. With a long lens these additional elements won't be sharp, but they will still draw the eye and help tell the story of the photo. This technique can add a great deal of visual power to your photograph.

Although telephoto lenses are usually the largest and heaviest of the three lens types, they're indispensable tools for shooting adventure, action, and wildlife or for isolating specific elements in the landscape. If you make the effort to bring them into the backcountry with you, you'll be able to create some amazing imagery, even if they do slow you down a little bit.

Telephoto Lens Techniques

- » Wildlife, sports, and action
- » Isolating specific subject matter
- » Tack-sharp subjects with soft-focus backdrop
- » Narrow/distant landscapes
- » Larger-than-life backgrounds

COMPOSITION

Composition in photography is the act of arranging subject matter so that your photo effectively communicates a specific idea or feeling to your viewer. A well-composed picture draws viewers into the shot, engages their brains, and gets remembered long after they've moved on. A poorly composed picture is simply a snapshot.

Before taking any photo, you need to decide what goes into the frame and where to put it. Next you need to decide what *not* to include. This second idea is very important.

Don't Show Everything

Good photography isn't about re-creating every single aspect of real life—it's about abbreviating and suggesting real life. When you compress real life into the confines of a single image, it often fails to evoke a very strong response. We see real life every day, and there is little artistic insight to be gained from an exact copy.

An image that tells a unique story or presents the abridged version of a specific event or moment is much more engaging, because we imagine that moment for ourselves.

This is a hard concept for many beginning photographers to comprehend. In trying to capture the entire scene with their camera, they often include way too much stuff in the frame. This confuses viewers, because they don't know what they're supposed to focus on. The result is a picture that is quickly forgotten.

It's easy to see how this happens. The world is filled with fascinating objects and details: trees, trails, mountains, boulders, climbers, skiers, ropes, icicles, cloud formations, wildflowers, alpine ridges, kayaks on the lake, your friends' expressions as you reach the summit together, the brilliant pinks of sunset . . . the list is endless. How could you not want to show all this stuff?

Keep It Simple

The trick is to show only what you *need* to show and leave out the rest. Every single element in your composition should sit comfortably within the frame and play a vital role in telling the story or indicate the location or mood of your scene. In turn, each element should somehow relate to the other elements in your frame.

Exclude any subject that detracts from the overall impact of the image. Remove all the unnecessary elements in your photo, and only give your viewer the

Tightening up your composition often creates a more powerful shot.

bare essentials. Try and keep the borders clean. Treat the viewfinder like your canvas, or your novel. Start editing even before you take the shot.

Your goal with photography should be to tell the story with as few words or brushstrokes as possible. Don't try to throw in too many subplots; keep it simple. Minimalism goes a long way here. Give your viewers as little information as possible, and they'll use their brains to fill in the rest. Anytime you activate your viewer's brain, you've gone a long way toward creating a memorable photograph.

FRAMING

Where you place your subject elements in the frame determines the overall balance of your composition, and it can make the difference between an interesting picture and a boring one. A good image brings your viewers into the shot and lets them play an active role in the process. It causes tension without confusing them. Here are some simple techniques you can follow to increase the visual power of your compositions.

Avoid the Center

The human brain is geared for pattern recognition. As we move through the world, this evolved trait helps us process everything we see in order to quickly identify things like food, danger, and familiar settings. Once

we find the expected order in our environment, our brains tend to relax until we move to a new setting.

The same is true with photography. When you place your main subject right in the middle of the frame, your viewers' eyes will go right to it like a dart to the bull's-eye. Their brains will quickly establish this perfect order and move on; in their minds there's nowhere else to go. Mentally they're already done with the picture, and they'll soon forget it.

But what happens when you place your subject in a random area of the frame, away from the center?

Recomposing so that the subject is off-center leads to a much more compelling image.

Since there's no easy and perfect sense of order for your viewers to recognize, their eyes will wander around the frame and explore all of the different elements. They'll stay mentally engaged with the photo for much longer, trying to spot order that isn't there. This subconscious visual tension holds your viewers' attention and makes for compelling and memorable photos.

Avoid the Edges

Just as you want to avoid the middle of the frame, you don't want to place important subject matter out at the edges either. This makes your photo look sloppy and cluttered and can confuse your viewers. Try not to let any person or animal in your picture touch the edges of the frame unless you're trying to achieve a specific look with the shot.

Also, don't cut off anything too close to the edge of the frame, like tree branches or cloud formations. This creates the impression that you weren't even sure yourself if the element should have been included in the picture or not. Again, it looks sloppy. Anything in the frame should be there for a reason, not by accident.

The Rule of Thirds

If you draw imaginary lines that break up the viewfinder into thirds, both horizontally and vertically, you end up with four points where the grid lines intersect

around the center of the frame. The locations of these points don't immediately imply any sense of specific order or pattern: They're far enough outside the middle, and at the same time they're not close to the edges.

If you place your main subject(s) on any of these intersections, you'll create a look that *feels* random with just the right combination of tension and comfort. The rule of thirds works so well because it's based on common proportions found in nature. You don't always have to follow the rule per se, but by keeping subjects out of the center and away from the edges, you inherently create dynamic yet comfortable images. Experiment with your own placement.

Using the rule of thirds for optimum framing. The bright red jacket also helps makes the image pop!

RELATIONSHIPS

A great subject alone is not usually enough to make a great image—you need to show it in context with the world around it. A compelling image should tell a story, and if you leave out context, you don't have a story; you just have a subject. To build a story, you need to include other elements that help suggest the relationship between your main subject and the rest of the world.

Secondary elements give your photo a sense of place and go a long way toward establishing the flavor or style of your image. In photography style is not so much about *what* you shoot but *how* you shoot and how you accentuate specific relationships with your subject.

The relationships you create in your composition reflect your own creativity and ideas about the scene. Oftentimes they comprise specific background elements, or they might be the way the light, shadow, or fog accentuates or highlights your main subject.

For example, while shooting trail running, you could choose to focus on the winding trail and the dramatic mountain peaks in the background. This might tell the story of remote solitude in a rugged environment. Or you could show the runner's position on the ridgeline and draw attention to his or her location high above the valley floor. Perhaps you might include other runners in the background to suggest competition or companionship.

Each element should add to the scene in such a way that if you removed any one of them, the picture would lose power. At the same time you don't want

Prominent elements in the landscape (the sheer rock face in the background) can help tell the story.

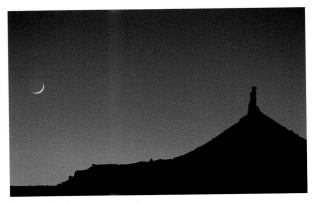

Keep it simple.

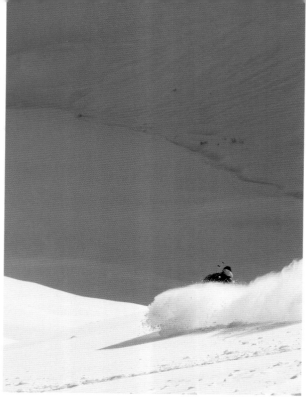

Don't be afraid to leave large, open areas in your image.

to clutter the photo with too many things, or your viewer won't know what to focus on. Keep it simple: one main subject and just enough other stuff to tell a compelling story. No more.

Empty Space

Generous portions of empty, or negative, space can be a powerful compositional tool in photography. By

placing your main subjects against large, open backgrounds, not only do you make the subjects stand out more, but you create a stronger sense of balance in your photos.

Empty space can comprise large, shadowed areas; expanses of open sky; or clean, uncluttered parts of a landscape. The amount of empty space you use depends on the strength of your main subject; generally, the more powerful the subject, the more space you can include around it. By combining this technique with other compositional methods, you can create some very dramatic and eye-catching imagery.

COLOR

Human vision is highly color sensitive. In fact, a large percentage of the visual information we process is related to color. The survival of our ancestors depended on the ability to distinguish different hues in nature in order to identify food and possible threats, and throughout history our unique affinity for color led us to equate it with specific concepts like tradition and emotion.

The most prominent colors in the spectrum are red and orange: the colors of blood and fire. These "hot" colors project excitement and immediacy and quickly catch the eye. Even a spot of red or orange will draw your viewer right into the shot. Yellow, the

"warning color," also falls into this category. Too much yellow can overpower the scene, so use it more sparingly.

The "tranquil" colors, green and blue, project stability, serenity, and timelessness. These are the colors of grass, forests, meadows, tundra, oceans, and the

A brilliant blue background is an empty canvas for a brightly colored subject. Imagine a skier in a red jacket here.

sky. We're used to seeing large swaths of these colors in life, so they make for great backgrounds. Mix in warm colors for even more drama. One effective method is to outfit your models with brightly colored clothing and backpacks.

CONTRAST

Even more than color, contrast draws our eyes the most. You can incorporate color contrast into your photography in a number of ways: cool colors with hot colors or primary colors with secondary colors. (Colors that are opposite each other on the color wheel, such as orange and blue, carry strong interest.) These combinations can add a lot of visual appeal to your photographs.

Contrasting warm with cool, and light with dark.

DETAILS

The world is full of details. Everything around us is made up of individual attributes that make up the greater form, and depending on where our interests lie, we all notice them differently. Moving in close and shooting the details of a scene is a great way to create images that truly reflect your personal view of the world.

As with any type of scene, a good detail photo should draw your viewer in and hint at what lies beyond the borders of the photo. It should give viewers just enough visual information to make them imagine the rest of the scene. Again, anytime you can invoke the imagination of your audience, you have created a more successful image.

Detail shots work well with any type of lens and compositional technique. Let's explore a few creative considerations that you can use to make your detail shots stand out.

The Single Detail

Sometimes your images will show a single aspect of the scene without giving any other information about its place in the world, other than what is inferred from the subject itself. When shooting the single detail, make sure you focus on creating a simple yet powerful image. Since your subject matter will be limited, the strength of your photo will depend on a good composition and compelling lighting.

Details That Give a Sense of Place

Give hints about how the subject relates to its surroundings. By including information that tells a greater story of the scene, you can give your viewers a reference point that indicates the location or story of the photo.

Larger Details

Detail shots don't always have to be photographs of smaller objects, and they don't always have to be taken up close. You can focus on any detail, provided you can accentuate the subject in a visually appealing way.

Human Details

There is endless variety to the details of the human form and its actions. Focusing on particular aspects of human interaction, motion, expression, or relationships with the world can lead to very powerful imagery.

Textures

Sometimes the photo can be more about simple graphic form than a physical object. Experiment with

shapes, colors, textures, patterns, and other abstract subject matter that appeal to you. Shadows often make for striking detail images.

LINES

Lines play an important role in photography either as prominent subject matter or as invisible pathways that help direct your viewer into and around your composition.

Lines suggest movement and motion within your photo. They can point to specific subject elements or lead your viewer between some of the different elements within the frame. Lines that travel from front to back add a great deal of depth to the shot. A photo without any lines is often very static.

In outdoor photography, lines can be actual or implied. Mountain ridges, trees, trails, paths, ski tracks, ski poles, climbing ropes, and sun rays in the fog are examples of actual lines. Implied, or suggested, lines

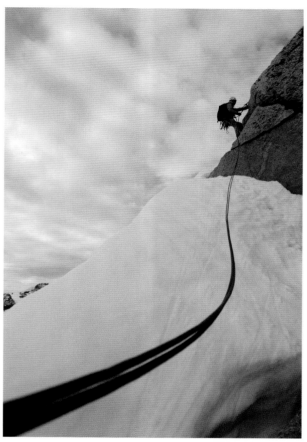

The rope draws an actual line to the subject.

are less obvious but effective visual pathways that you might create through the use of certain compositional elements, such as color, shape, light; the

Here I use the actual line of the ski tracks and two implied lines: the foreground ridge and the background mountain ridge. All three lines converge on the subjects.

direction a person is looking; or the shape or position of one or more objects within the frame.

Look for lines when you're building your compositions, and use the following ideas as a guide:

>> Horizontal lines imply a peaceful, tranquil feel.
>> Diagonal lines create much more dramatic motion and excitement in the shot.
>> Lines that travel front to back, such as those accentuated with a wide-angle lens, add depth and three-dimensionality to the shot.

MOMENT

Henri Cartier-Bresson's famous term "the decisive moment" refers to capturing a single fleeting moment and preserving that instant forever as a still image. In real life these decisive moments usually occur too fast to recognize, but if you click the shutter

at exactly the right time, you can turn a split-second event or expression into an iconic photograph that communicates a great deal of power.

On the other end of the spectrum are insignificant moments that are no different from the majority of moments previous to and following that one instant. However, through your own unique vision and technique, you can turn a static subject or scene that has probably been photographed by many other people into a highly individual image.

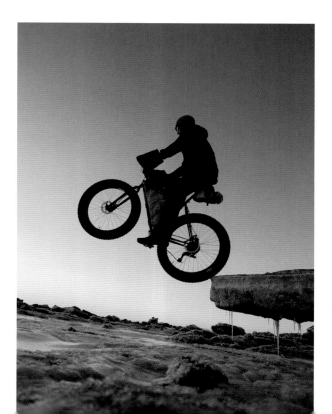

Photos of action, adventure, people, expressions, and wildlife often fall into the decisive moment category, while landscapes and travel photos are often more static in nature. Great photographs can be made with either method, and I encourage you to go out in the world and look for decisive moments as well as static subjects that you capture in your own creative way.

VANTAGE POINT

Most people shoot photos from the same vantage point: standing up straight while holding the camera to their eye. Consequently, this means there is very little variation in how most images look.

Varying your vantage point is a simple yet very effective way to give your photos a unique look. Because we're used to looking at the world from eye level, any photo shot from an uncommon vantage point will inherently look more interesting.

There are many ways you can alter your vantage point. Simply standing on top of a boulder or the roof of your car, crouching down, or lying on the ground will add a unique twist to your shot. More-elaborate methods might involve getting your camera to a higher or lower position, whether by rigging it to something and shooting remotely or climbing with your camera up the side of a cliff or into a tree.

You don't always have to shoot while looking through the viewfinder. Try shooting from the hip,

or shoot while holding your camera over your head, next to the ground, or extremely close to your subject. Attach the camera to your bike, to the top of your ski pole, or to another moving object. All of these methods can lead to some very dynamic imagery.

Be careful, though. You don't want to endanger your camera—or yourself.

FOCUS

The concept of focus plays an important role in how your images look. By varying the amounts of sharpness in different parts of your composition, you can dramatically alter the story of your photographs.

Earlier we learned that small apertures give you a wide depth of field and maximum edge-to-edge

sharpness from front to back. This technique works extremely well with grand scenes that are shot with wide-angle lenses. By stopping the lens all the way down to f/16 or f/22, you can create images in which nearly everything in the frame is sharp.

By contrast, using a shallow depth of field allows you to isolate your subjects with sharp focus against a soft background. This technique will draw the viewer's eye right toward your subject, because it's the sharpest thing in the frame. Portraits and close-ups work well when shot this way, but don't limit yourself to these subjects when using wide-open apertures. You can create very engaging and compelling images of any subject by using a very shallow depth of field.

One of my favorite techniques is to focus on an element in the frame that *isn't* the main subject and let the rest of the frame blur out. This gives your viewer an unexpected starting point along the visual pathway toward the main subject. It can be an effective tool, because it goes against the traditional notion that says the main subject needs to be in focus.

Keep in mind that this technique only works if your "sharp" object is closer to the camera than the "main" subject. If the point of focus is behind your main subject, it will just look like your autofocus wandered right before you pressed the shutter.

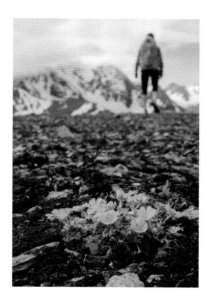

Our eyes start at the yellow flowers, but then track back toward the hiker and the mountain background.

FORMAT

Cameras aren't specifically oriented to shoot horizontally, but that's how we tend to hold them. Don't forget to flip your camera up the other way. Get in the habit of shooting vertically. If you ever want to get your photo on the cover of a magazine, you'll need to shoot vertically.

Some subjects lend themselves to being rendered as verticals, while others work better as horizontals. Let the subject matter and your own vision for the scene dictate how you capture the shot; if

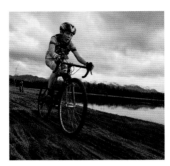

Vertical view (left) and panorama (below).

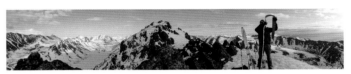

you're unsure, shoot both and decide later which one you prefer.

Modern cameras offer a variety of aspect ratios and special effects modes. Shoot in Square or Panorama mode, or play around with different color settings. Experiment freely and see what you like; you might find that using a different format gives you a boost of creativity.

BE A DIRECTOR

Great images don't just happen; you've got to make them happen! Don't just point, click, and hope for the best. Come up with a creative idea, grab the moment with both hands, and get to work!

Being a good photographer is as much about being a director as a camera operator. This means thinking ahead and giving your friends instructions that pertain to location, timing, and activity. It might involve telling them to stand on a pronounced rock outcrop, to run or hike in a certain direction along the trail, or to wait for the clouds to clear before starting their run down the slope.

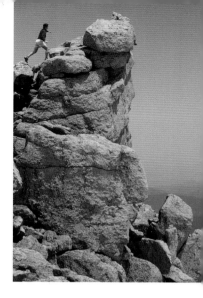

Most successful outdoor photographers use a significant amount of direction when they're shooting, and you should learn to bring that element into your work as well. As soon as you go beyond the passive act of capturing random moments and actively producing the scene as you see it in your mind, you'll start making much more powerful and compelling imagery.

Don't worry if your idea doesn't pan out—mistakes and missed shots are all part of the creative process. Even professional photographers make more bad images than great ones. Keep your ideas flowing, and keep pressing the shutter over and over again. Eventually, you'll make some great photos. I promise.

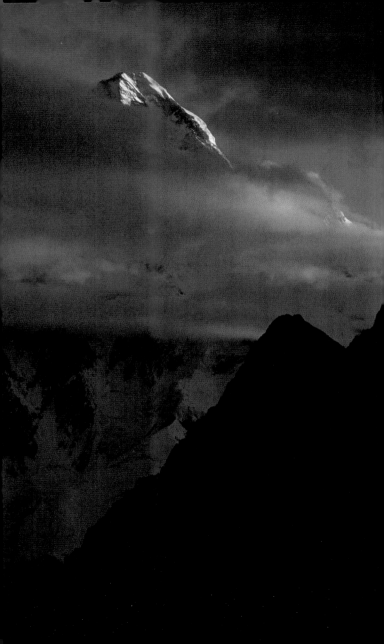

Chapter Six

Classic Outdoor Subjects

LANDSCAPES

Landscapes have long captured the fascination of adventurers and outdoor photographers. Ever since cameras were invented, explorers have carried them into the wilds to document the mystical, rugged, and serene beauty of the natural world. Fortunately, today's cameras are easier to carry than the large wooden boxes that people like Ansel Adams used to lug around.

Great landscape photography has the power to inspire feelings of adventure and awaken desires for exploration. For this reason many people begin their discovery of photography with landscapes. While some photographers branch out into other styles, others devote their entire creative lives to shooting this genre.

Here are some tips to get you started.

» **Get out there:** The best way to make great landscape photos is to go explore the wilderness with your camera, not just once, but over and over again. Get up early. Stay up late. Sleep outside. Chase light during magic hour. No matter what kind of camera gear you have,

nothing beats putting yourself into amazing locations.

This doesn't mean you can't take great photos in your own backyard. Don't fall into the trap of thinking you need to venture to distant lands or trek into rugged mountain terrain to shoot compelling landscapes. Natural beauty exists everywhere—you just have to grab your camera and go find it.

» **Look for magical light:** I'll say it again—everything looks better in dramatic light. Shooting in magic hour and blue hour will always make for more-compelling images. Go one step further and scout locations that you can revisit when the light gets good.

» **Look for a defined subject:** Great photos feature one or two prominent elements and their connection with the rest of the scene. When placing your subject, create visual pathways that lead your viewer between foreground and background elements. Don't crowd your picture too much; give your subject room to breathe.

» **Look for convergence:** Search for places where natural elements converge in the

Use a Tripod

Not only will a tripod hold your camera still and ensure sharp photos when using slow shutter speeds and narrow apertures, but the opportunity for active thought when using tripods helps you become a better photographer.

When your camera is fixed to the tripod, it gives you the freedom to walk around; survey your scene; and think about your exposure, composition, and overall approach. You can make small adjustments while you're waiting for the light, and even take notes. Anytime you're actively thinking about your photographic process, you're improving as a photographer.

landscape: where earth meets water or sky or where warm colors meet cool. These are places that let you show contrast and relationships in nature: rushing streams against still grasses on the bank, reflections, waterfalls, golden peaks against the cool blue sky, light against shadow—the possibilities are endless.

LITTLE PEOPLE IN THE BIG WORLD

Want to create the quintessential adventure shot? Add a person to your landscape. This brings your shot into a whole new realm. The image is no longer about just the wilderness; it is about our interaction with it. These shots communicate our relationship to the world and how we fit into it. The human figure also creates a powerful visual target that draws your viewers in and immediately connects them with the scene.

The secret to creating a powerful image of a person in a landscape is to shoot an impressive landscape. Even though you have a person in there, the landscape is the real star of the shot, so you'll want to wait for the most dramatic light and use your best compositional skills to create the right setting for your person.

Where Does the Person Go?

Look for elements that might offer you an obvious starting point, such as a trail, ridge, or steep hillside. Once you have the framework, use the rule of thirds

to help you fine-tune your subject placement, or else look for a way to balance the subject against another element in the photograph.

How Big Should the Person Be?

I like to call these "little people in the big world" photos. That gives you an idea of how big I like my people

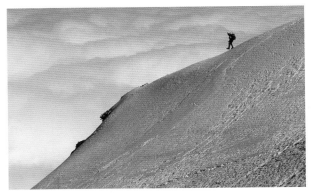

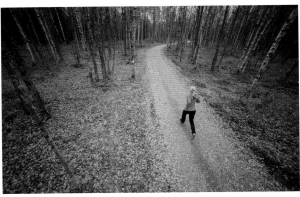

subjects to be. Remember, this kind of shot isn't about the person; it's about a human presence in the scene, so even a very small subject can be quite effective. Factors such as distance, vantage point, and lens selection will ultimately determine how big your person is in the frame, so experiment until you come up with a composition that gives you the right feel.

ACTION

Intense action shots are a mainstay of adventure photography, and they're all about the wow factor. This is where you bring the viewer in close and show those peak instants when dirt, snow, and mud are flying all around your subject. It's all about capturing significant highlights and decisive moments. If you do it well, your viewers will feel like they're right there with you in the middle of the scene. They'll be able to revel in all the excitement, fear, and struggle that you and your subjects experienced firsthand when you took the shot.

Wide-angle lenses are great for shooting action, because they give you the up-close perspective. This can add lots of drama to your photos. Immerse yourself into the scene, and try to get as close as possible to your subject. Try focusing on a specific aspect of the foreground, such as a climber's hand reaching for a hold.

Telephoto lenses let you zoom right in on the action from afar and isolate peak moments and

expressions. With either type of lens, you can increase the power of your action photos by shooting from exciting vantage points. Time spent scouting for the ideal location from which to take your shot will pay off in a big way.

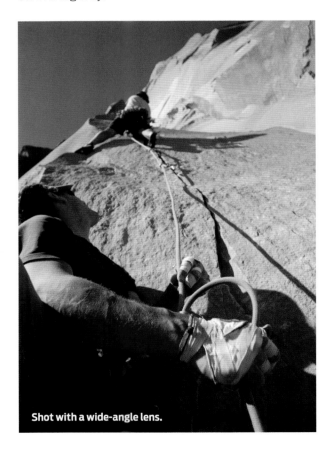

Shot with a wide-angle lens.

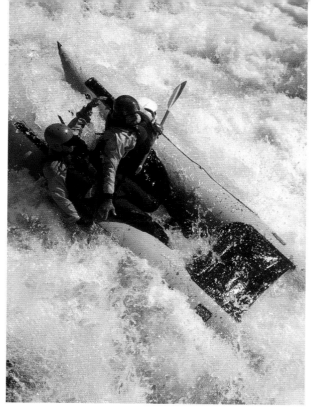

Shot with a telephoto lens.

Understanding the activity you're shooting allows you to be more comfortable being immersed in the scene with your subjects. You'll also be better able to anticipate where the peak action will unfold. Shooting as an active participant, not just an outside viewer, is often an integral part of adventure photography.

PANNING

Panning is an essential technique for shooting sports and action. By using a slow shutter speed and following a moving subject with your camera as you take the shot, you create a feeling of flowing movement within your image. The most effective look when panning is a sharp or slightly sharp subject in motion against a blurred background. This contrast of sharpness versus blur between different elements of your photo can make for a very dynamic effect.

While there are no set rules for panning, here are some guidelines to get you started. Ideal shutter speeds for panning are usually under 1/30 seconds, but this will vary with lens selection, distance from the subject, and speed of the subject.

Since telephoto lenses magnify the scene, they'll also magnify any motion within the scene, so you can get by with a slightly faster shutter speed. The opposite is true with wide-angle lenses; you might find that speeds of 1/4 to 1/8 seconds create the right look. With a midrange or normal lens, start with 1/8 to 1/30 seconds and adjust as needed, depending on the effect you're going for.

There's a fine line between what works and what doesn't with this technique. If you use a shutter speed that's too fast for panning but not quite fast enough to freeze the subject, you won't create the feeling of motion. You'll end up with a mess that doesn't quite work either way.

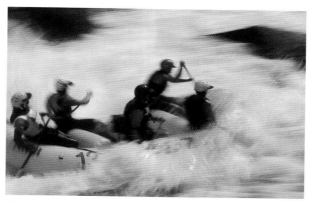
Shot with a telephoto lens at about 1/60 seconds while panning with the action.

If your shutter speed is too slow, your shot may be overly blurry where nothing is sharp. It's hard for the viewer's eye to lock onto pictures that have too much motion; photos need at least one sharp element to anchor them.

Front-to-Back Panning

In addition to regular side-to-side panning, you can also pan from front to back (or back to front). In effect, the camera is moving *through* the scene rather than *across* it. This unique perspective brings your viewers right into the action, instead of making them feel like they're watching from a distance.

The technique is simple in theory, although it can be challenging to nail a shot that looks right. Using a wide-angle lens, set your desired shutter speed

Shot with a wide-angle lens at 1/10 seconds while walking behind the subject.

and shoot continuously while you follow the action, as if your camera is attached to a boom or a moving vehicle. The trick is keeping your camera in consistent motion behind (or in front of) your subject while you pay attention to both the subject and the terrain so you don't go careening into the dirt.

I recommend holding the camera at arm's length and watching the LCD screen to see what you're shooting. It's pretty hard to look through the viewfinder when you're doing this, especially if you're on a rocky trail. Tilt-screen LCD panels make it easier to hold the camera close to the ground so you can get those really low vantage points. This is where mirrorless cameras have the advantage.

PORTRAITS

Adventure portraits tell stories about the personal experiences your subjects are having in the moment. They relay the human elements of excitement, fear, struggle, exhaustion, success, and elation and bring the aspect of personality to your imagery.

Good portraits have the power to wow viewers even more than action shots, simply because they intimately connect your audience. No matter what style you're shooting, people always make for compelling subjects, and capturing the human side of adventure can lead to impactful photos.

This kind of imagery will definitely test your skills, so don't get discouraged. It's even harder to capture the fleeting moments and expressions that make for a great portrait when you're immersed in the adventure as well. You'll need to shoot many frames to get that one great moment. Don't worry if you get lots of bad shots—keep trying, and eventually you'll nail it.

The Best Lens for Shooting Portraits

You can actually get a great portrait with any lens. Short telephotos are ideal for head-and-shoulders portraits because they make your subject pop against a soft background without overly flattening the scene. They also allow you to shoot from a comfortable distance without invading your subject's personal space. Longer lenses accentuate these effects even more.

Normal lenses are versatile portrait lenses. Up close they have a very shallow depth of field, and if you back up a little bit, you can include some background elements to show relationship.

Wide-angle lenses let you move in close and still show your subject in context with the environment. They're not very flattering at extremely close range, though, because they distort facial features.

Here are some additional tips that will help you enhance your people shots.

» **Use great light:** I'll say it again: the better the light, the better the photo. When shooting adventure portraits, take advantage of the brilliant, dynamic, warm hues of outdoor light. This will add lots of drama to your shot.

» **Watch for the decisive moments:** Great portraits often revolve around expressions. In the outdoors these can be rooted in moments of concentration. If you're able to anticipate these moments, you'll be in a better position to grab them right as they happen.

Shot in late afternoon sunlight with a wide-angle lens.

Capturing expressions and moment—shot with a 50mm normal lens.

» **Use face detection AF:** It's hard enough to concentrate on changing expressions and light with moving subjects, even without trying to nail the focus. If you have Face Detection AF on your camera, use it. It's there to make your life easier at times like this.

Shot with an 85mm short telephoto lens.

» **Use burst mode, or good timing:** Burst mode, or continuous mode, isn't just for action; it's essential for capturing expressions that can shift in the blink of an eye. By shooting small bursts of two or three frames at a time, you'll have a much better chance of nailing the perfect moment. Other times it's better to pay close attention and then click a single frame at the precise moment.

» **Vary your approach:** Portraits don't have to be traditional head-and-shoulders shots. Experiment with different concepts and techniques. Shooting really close gives an intense, intimate viewpoint; if you back up and shoot from a low angle, you'll create the "hero look." Be open to anything, but

A pair of similar scenes, the first shot with a long telephoto, the second with a wide-angle lens. A low angle gives the "hero look."

most importantly, pay attention and be sure to interact with your models. The more comfortable they are with you, the more likely they'll be to let their guard down and let you capture the ideal moment.

NIGHT PHOTOGRAPHY

Nighttime offers unique opportunities for outdoor photography. After blue hour, when all traces of sunlight have faded, when you're out in the wilderness away from city lights, you can turn your attention to capturing the vast beauty and majesty of the night sky: star trails, galaxies, the moon, lightning, and the aurora. Here are a few tips for shooting after dark.

» **Tripod:** Astrophotography, as it is called, requires long exposure times, and a tripod provides the necessary stability and support you'll need when the shutter is open.

» **Gear:** While a full-frame camera gives you better low-light performance, most DSLRs and mirrorless cameras will give you good results. The same goes for lenses. Use the glass you have. Wide-angle to normal lenses offer the best view for capturing the night sky. Fast lenses are preferable, but they're not essential. You'll also want to keep extra batteries handy. Long exposures use up the juice pretty quickly.

» **Camera settings:** Turn off Auto ISO and set the camera to the lowest ISO possible. This will keep noise to a minimum. If your photos are still too dark, adjust to a higher setting until you get a clear exposure. Use Manual exposure mode and turn off the flash. Put the camera on B (Bulb) mode, which will keep the

shutter open as long as it's held down. Stop your lens down at least one or two stops from the widest setting for maximum sharpness.

» **Exposure times:** Your shutter speeds will vary with ISO and aperture. For shooting general night scenes and the aurora, start with 10 to 30 seconds and adjust as necessary to achieve your desired brightness. To capture long star trails, shoot anywhere from 15 seconds to 2 hours. Point your camera toward the North Star to create a circular trail effect.

» **Camera shake:** To avoid camera shake, trigger the shutter with a cable or electronic release and don't bump the camera during the exposure. If you don't have a cable release, try to keep your finger very still while you hold the shutter button down.

Astrophotography requires a great deal of experimentation, but with practice you can create some amazing photos of the sky.

Chapter Seven
Field Techniques

Whether you're a weekend warrior or if you spend weeks at a time in the backcountry, you're likely to find yourself in amazing locations with diverse, exciting subject matter. You now have the technical and creative skills to capture powerful images and tell compelling visual stories about your adventures and experiences in the outdoors.

However, in real-world situations, when you're out there in the elements, moving over the terrain under quickly changing light, skills and knowledge only get you so far. You've got to have good field technique. You've got to learn how to carry and incorporate your camera into your active outdoor lifestyle so that when the moments unfold, you're ready.

Adventure photography requires active participation, both physically and mentally. Not only do you need solid camera skills, you must also be fit enough so that you can be both explorer and photographer at the same time. Getting a great shot often requires running or hiking ahead to a vantage point or reacting quickly when you see light and moment about to converge. Believe me, outdoor photography can be a physically demanding, high-energy activity, and the better shape you're in, the easier it will be.

In this chapter I'll cover methods for packing your camera gear so it's both accessible and secure, given

all the conditions you're likely to face in the outdoors. I'll also give you a few field tips designed to make you a more well-rounded photographer.

CARRYING YOUR GEAR

If there is one mantra that will help you take better photos in any circumstances, it's this: *Always have your camera accessible.*

The world flows in constant motion. In a brief moment any number of elements can change and make or break the shot, including light, expressions, weather, backgrounds, and body positions. An interesting scene can evolve into an amazing scene within seconds, and if you don't have your camera ready, you'll miss it.

Of course, it's not always practical to keep the camera around your neck when you're hiking, skiing, or climbing. As an adventure photographer, you'll often find yourself alongside your subjects in some pretty rugged or exposed terrain. You need a good bag that will keep it secure without hindering quick access.

Here are a few different ways to carry your camera.

Pocket or Strap

A pocket (or a tiny belt pouch) is a great place to keep your point-and-shoot. Compacts and small mirrorless cameras are usually light enough to carry by the strap. Both of these methods offer excellent accessibility, and if your camera is small enough, it won't bang around too much. If you carry it around your neck, stick one arm through the strap and sling the camera around to your side when you're on the move; this makes it even more secure. If things get hairy, you can always hide it inside your pack, but keep in mind that it won't be very accessible there.

Photo Packs

With larger mirrorless cameras and DSLRs, you'll want a system that offers additional protection for use in rugged terrain and changing weather.

Chest or waist pouches protect your gear from the elements and offer great accessibility. With the right setup you can get your camera out of the bag and into your hands within seconds. This system works quite well with most cameras, but it can present challenges if you've got a bigger lens attached to the body or if you're engaged in a highly technical activity like rock climbing.

Technical photo backpacks are specifically designed with adventure photographers in mind. They have a main compartment on top for your regular outdoor gear and a separate, dedicated compartment that offers quick access to your photo gear. Some even offer technical features like rain covers, side pockets, ice ax/trekking pole loops, and hydration pockets.

The Lowepro Photo Sport 200 with side-access camera compartment.

Lowepro, f-stop, Clik Elite, Tamrac, Gura Gear, Naneu, and MindShift all offer solidly built technical packs in a variety of sizes and configurations. With all

the available options, you should have no trouble finding a bag, whether you need one for day outings or multiday backcountry excursions.

PROTECTING YOUR GEAR IN TRANSIT

Cameras can withstand varying levels of abuse. Pro-grade cameras are built with all-metal bodies, rubberized grips, and weather sealing. They're designed to keep functioning even in the most demanding and harsh environments. Consumer-grade cameras are not nearly as durable, so you'll want to be more careful about how you handle them in the outdoors. No camera is indestructible, so you'll need to protect your camera when traveling and shooting in extreme conditions.

A regular photo backpack or camera pack will keep your gear safe in most situations while you're traveling, whether you're driving a bumpy gravel road or flying across the continent. (I always recommend taking your camera gear as carry-on luggage whenever possible.) For more protection you can always pad your camera bag inside a separate duffle.

If you require even more protection for distant expeditions or extended airline travel, look to hard-shell, gasket-sealed Pelican Cases. "Pelis" are dust-proof, crushproof, and waterproof, and they come with pluck-away foam inserts that let you customize your gear storage. Some Pelis are even configured

like roller bags with handles, which makes them even easier to transport.

Every day thousands of photographers, videographers, and movie industry professionals use Peli cases to transport their gear on airplanes, jeeps, trucks, buses, trains, speedboats, camels, horseback, and pack mules. Most of the time their gear arrives just fine.

SHOOTING IN BAD WEATHER

If you only shot photos when it was sunny, you'd miss a lot of great photo opportunities. Foggy, wet weather makes for ominous landscapes, and nothing screams "adventure" like photos of people suffering through a downpour or braving sideways snow. However, bad weather and cameras do not always mix. Excessive water can wreak havoc on the electronics and shut the whole thing down. If you're lucky, your camera *might* work again when it dries out. Note: I said "might."

If you don't have a weather-sealed camera, I recommend loosely covering it with plastic or placing it inside a bag. Under heavy rain you can duct tape the bag closed around the edges of your lens hood. A hood will also help keep water off of the lens.

When shooting in the rain, you should regularly check the lens for water. Keep it as dry as possible. A few small drops might look cool in your photos, but really large drops will probably ruin your shot. Keep a lens cloth or cotton bandana handy so you can wipe

excess water from the lens. Your polypro shirt is not very absorbent; if the lens is wet, you'll just smear the water around.

Be extra cautious when shooting around salt water. If seawater gets inside your camera, it will corrode the tiny electronic components and turn your camera into a very expensive paperweight. A camera *might* survive a quick dunk in the lake. The ocean? Not so much.

If you shoot often in wet weather or from watercraft, you might consider purchasing a dry bag or an underwater housing. ewa-marine makes affordable housings for DSLRs and mirrorless cameras.

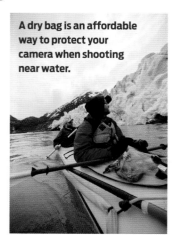

A dry bag is an affordable way to protect your camera when shooting near water.

If your camera gets excessively wet or stops working, turn it off and remove the battery. Store it in a warm, dry place overnight or put it inside a bag of rice for a day or two. Holding it near a campfire or wood

stove for a few minutes works too. Be careful though, don't get it too close! You're looking for warm, not hot. Once all the moisture has evaporated, there's a chance it will work again. If it doesn't, you'll need to take it in for repair.

COLD-WEATHER PHOTOGRAPHY

Every activity seems to look more extreme and rugged in the wintertime. Portraits take on a special quality in winter, with elements like frosted hair and beards and the sheer determination of braving frigid temperatures. Winter also adds beautiful details to the landscape as hoarfrost crystals cling to sticks and tree branches, snow piles up on objects, and ice and snowflakes reveal detailed textures and geometric patterns.

"Less is more" when composing winter imagery. Snow imparts such a magical, surreal quality that you don't need very much stuff in the frame to tell a compelling visual story. A little bit goes a long way toward creating a scene that draws the viewer in. Remember that you're not trying to show everything in your photos; you're trying to evoke a mood.

Regardless of what kinds of subjects you like to capture, here are a few things to keep in mind when you're out shooting in this most magical of seasons.

Light

Days are shorter in winter, but this means that magic hour usually lasts longer. On clear days the low winter sun can bathe everything in soft, warm hues of pink and orange, even in the middle of the afternoon. Unlike in summer you can photograph the sunset and be home in time for dinner, so take full advantage of this colorful illumination whenever you get it.

Experiment with direction; try putting the sun directly behind your subject or off to the side. The low winter sun works especially well for adding golden rim light and dramatic sidelighting to portraits. Snow also acts as a giant reflector. It reduces contrast and fills in shadows that you would normally need to fill in with a flash or a handheld bounce card.

Subjects tend to look flat and dull when shot in direct shade and under overcast light, especially in winter. To liven up shadowed subjects, compose

more tightly. Accentuate the action, expressions, and details, leaving out as much sky as possible. Look for bright colors and powerful moments. They won't stand out as much in the shade as they will in bright sunlight, but a great moment can rescue any photo.

Most modern camera meters will correctly expose for snowy scenes when shooting in bright, sunny conditions. In the shade you might have to compensate and increase your exposure by about one full stop. If your photos still end up too dark, you can always brighten your exposure with your post-processing software.

Dealing with the Cold

Most cameras work fine even in subzero temperatures. However, there are two very important things to keep in mind with regard to camera gear when you're photographing in the winter.

Batteries

If you haven't learned it by now, camera batteries don't work as well in the cold; they lose charge and die much more quickly. The key to successful wintertime

photography is to carry at least one extra battery that you keep in a warm pocket near your body. I usually keep mine next to a hand warmer in the chest pocket of one of my inner layers.

When your first battery dies, swap it out for the warm one and put the dead battery in your warm pocket. It might regain some of its charge after it warms back up. When the second battery gives out, you can swap it back with the first one again. You might do this back-and-forth battery dance a few times during the course of a cold day. Either way, you should never leave the house without at least two fully charged batteries when it's cold outside.

Condensation

This is a much bigger issue than cold batteries, so pay close attention.

Do not, under any circumstances, take a cold camera back inside a warm building, heated ski hut, yurt, or cabin if you intend to go back outside and shoot again. The warm air inside will condense on your cold camera, and if you take it outside again before it dries up, all that moisture will freeze. You could end up with ice on both the inside and outside of your lens. All your photography plans for the rest of the day will be thwarted, because there's no quick fix for a frozen lens. For the same reason, don't tuck your camera in and out of your toasty warm jacket when you're shooting in the cold; the same thing can happen.

If you must take your camera into a warm environment, put all your gear back into your camera bag or backpack *before* you go inside, and keep it in the closed bag until you go back outside. This will prevent condensation because the air temperature is already equalized inside your bag. If you stay inside for a long period of time, it will eventually warm up and everything will be fine. The key to preventing condensation is slow, gradual warming.

If you do experience condensation on your camera or lens, the only remedy is to keep the gear in a warm area until it completely dries out. (This can take up to a few hours.) Only then can you take it outside again. Note that there's no danger taking the camera from warm to cold; just don't take it from cold to warm and then back to cold again.

Dress for the Cold

Assuming you're experienced in the outdoors, you probably know the basics of dressing for long winter days: Avoid cotton, dress in layers, combine wicking with insulating material, and wear a hat.

Be prepared for quick bursts of activity followed by longer periods of inactivity, so dress accordingly and bring extra layers. Remember, the effects of cold are cumulative. A slight shiver can quickly degrade into bone-chilling misery and even hypothermia, both of which will negatively affect your photography (and possibly your life).

Warm hands are always a challenge when photographing in cold weather. Mittens and bulky gloves offer more warmth but make it hard to operate the camera. Thin gloves and bare hands offer better dexterity, but in cold temps your hands will quickly go numb. I recommend chemical hand-warmer packs and a good set of pockets, not to mention a spare set of gloves to throw on when you're done shooting.

Finally, watch bare noses on ice-cold camera bodies when it's really cold—you can frostnip the end of your nose when you press your face up to the viewfinder. Trust me; it's no fun. Wear a nose shield or face mask, or use the LCD screen to frame your photos. Your face will thank you.

ESSENTIAL EQUIPMENT

In addition to your camera and lenses, here are a few essential accessories that you may want to have while you're out adventuring with your camera.

» **Spare memory cards:** A single memory card (I recommend 16 GB or larger) will let you store thousands of JPEGs on a single card. You'll eat the space up much more quickly if you shoot RAW files or video. Carry at least one or two extra cards with you at all times—the more the better.

» **Notebook, journal, or note-taking app:** These are for recording information about

locations, light, exposures, weather, creative or compositional ideas, etc. Mentally processing your photography experiences will make you a better photographer, and the sooner you get your ideas written down, the less likely you'll be to forget them. My favorite two note-taking apps for iPhone are Day One and Evernote (Evernote is also available for Android).

» **Microfiber lens cloth:** It's vital to keep your lenses clean when you're out shooting in the elements. Keep a couple of these stuffed into your camera bag at all times.

» **Neutral density filters:** ND filters allow you to use slower shutter speeds and wider apertures in bright light. They're essential tools for long exposures and photographing flowing water. ND filters come in varying levels of darkness, such as −2 stops, −4 stops, all the way up to −10 stops. If your normal shutter speed is 1/60 seconds, a −2 stop filter will darken the exposure and let you shoot the same aperture at 1/15 seconds, and so forth

» **Graduated neutral density filters:** These filters range from dark to clear across the filter. They're useful for reducing contrast between bright skies and darker foregrounds when shooting sunset landscapes. By positioning the filter so that the dark area covers the sky, you bring the exposure levels between the two areas much closer.

» **Sunrise/sunset app:** Photographer's Ephemeris is a handy app that tracks sunrise and sunset times. It also shows you the angle of the sun across the sky in any location for every day of the year. It's useful for knowing when magic hour will appear and from which direction the sun's rays will hit your subject.

SHOOTING RAW VERSUS JPEG

Most cameras let you shoot in either RAW or JPEG mode. Let's compare these two formats and see why you might want to choose one over the other.

Camera sensors don't actually make an image; they only read the light. When you shoot a photo in RAW mode, the camera writes all of the sensor data to the memory card, along with a record of your current camera settings, such as white balance, exposure compensation, sharpness, and saturation. The image processor also creates a preview image, which is displayed on the LCD screen.

However, the RAW file itself isn't an image. To convert it to an image, you need to open the file up in a photo program like Lightroom, Photoshop, Photoshop Elements, Picasa, or iPhoto. From there you can adjust the photo and export the photo to another format, like JPEG or TIFF.

In JPEG mode the camera's image processor reads the sensor data and converts the information

into a final image. It permanently writes the current camera settings onto the file before compressing the color data and saving the image to your memory card.

Once the file is converted to a JPEG, none of the original sensor data or camera settings can ever be changed or adjusted again. Essentially, you've given the camera final say in how the image should look. You can adjust a JPEG file in your photo software, but you'll have much less tonal information to work with than if you had shot the scene in RAW.

A RAW file preserves all of the original sensor data, so you have a much wider range of tones to work with. Also, the original data are never lost or written over. Only the changes you make to the file are saved, which means you can always go back and start over.

Advantages to Shooting RAW

Shooting in RAW gives you the best-quality images with the greatest amount of detail and color information. With RAW you have full control over how you adjust the final photo, and you'll have a wider range of tones to work with in the digital darkroom.

This is an important concern when shooting high-contrast scenes. With JPEGs you can never rescue any data beyond either side of the histogram—you'll either get blown-out white or full black. Once it's gone, it's gone for good. With RAW you'll often be surprised at just how much highlight and shadow detail you can pull back from the edges.

Advantages to Shooting JPEG

JPEGs take up much less room on your memory card and your hard drive. (Typically, RAW files are five to ten times bigger than comparable JPEGs.) It's also convenient to shoot in JPEG; you don't have to worry about tweaking your images. It's the "what you see is what you get" approach. Plus, the special effects modes and film simulations you'll find on many cameras only work in JPEG mode.

Most cameras these days produce great-looking JPEGs, and unless you're dealing with very high-contrast subjects, JPEGs will save you space and time. If you're shooting scenes that don't push your histogram, and if you want to minimize your computer time, you'll find JPEG to be more than adequate for most situations.

PROCESSING YOUR IMAGES

Digital photography is rarely a perfect science. Even with the ideal camera settings, you'll often want to fine-tune your photos in "post." Short for *post-processing*, this is where you open images in your editing software and make adjustments to give them maximum visual appeal.

How much you adjust your photos depends on the specific shot and your own creative ideas. Some photos require a slight bump in brightness or saturation to make them pop. Other times you may wish to

crop the photo or experiment with more drastic color and exposure adjustments or add a vignetting effect. In these cases your processing becomes a vital step in how the final image appears.

Basic Image Editing

Photo editing can be an in-depth process, but I'll just cover the basics. Because most photo editing programs use a similar interface, I'll outline the common adjustment sliders you'll find in software titles like Adobe Lightroom, Photoshop, Photoshop Elements, and Apple iPhoto (now called Photos for OS X). Remember that you'll have much more flexibility for adjusting your images if you shoot RAW.

No matter what adjustments you perform, *use the histogram as your guide.* Each move of the slider will be represented on the graph. Most images should span the entire range from left to right without going over either side. Very light or very dark photos will be heavier on one side of the graph. This is okay, as long as the levels remain within the edges of the histogram.

White balance controls the color temperature of your image, and it's used to compensate for any color cast you might have in your scene. For example, when shooting under cloudy skies or in the shade, your images will have a pronounced blue cast. You can warm them up and make them look more natural by moving the **temperature** slider toward the yellow spectrum. (Note that white balance adjustments

don't work as well with JPEG images; they already have a dedicated WB setting written onto the file.)

Exposure adjusts the overall brightness of your image. If you only make one adjustment to your photo, simply move the slider until the right side of your histogram falls as close to the right edge as possible. This will give it more life. Most photos can benefit from a slight exposure adjustment.

Highlights rescues overexposed highlights that fall off the right side of the histogram. This is a very important and powerful adjustment, and as I said before, you'd be surprised at how much bright information you can bring back from a slightly overexposed RAW file. However, if the image is completely overexposed or if the file is a JPEG, then no amount of highlight recovery will help.

Shadows lightens up the dark parts of the image, and it's used to bring up slightly underexposed subjects or details lost in the shade. As with Highlights, you'd be surprised at how much shadow information you can rescue from a RAW image. However, due to the way that sensors record light, there is less information to start with in the darker tones, so moving this slider too much will produce digital noise in your image.

Blacks adjusts the darkest tones, essentially doing for the left side of the histogram what Highlights does for the right. Use it to either rescue shadow detail or increase the contrast range of low-contrast images, like those shot in the fog.

Clarity (called **definition** in iPhoto) is an interesting and useful tool. It adds contrast to the midtones and edges of your photo without adding noise. You can use it to make your photos stand out or to soften skin tones in portraits. Extreme adjustments create an HDR (high dynamic range)-type effect.

Sharpness increases the edge detail of the photo. Be careful here, because too much sharpening will also increase noise. **De-noise** or **noise reduction** does the opposite—it reduces noise and grain. However, use too much reduction and you'll soften the photo.

Saturation boosts the colors of your images. It's easy to overdo this effect; a little goes a long way. **Vibrance** (found in Adobe software) is a bit more versatile. It boosts colors without oversaturating the skin tones. Using a blend of these two adjustments can really make your images pop.

Dust Spotting

If you shoot outside, sooner or later you'll get dust inside your camera. You'll notice it most when shooting against lighter-colored backgrounds with wide-angle lenses and small apertures. The **spot removal** tool allows you to get rid of any noticeable dust spots or blemishes in your image.

Straighten and Crop

If you don't use a tripod, you can end up with slightly skewed horizons, which look sloppy. You can fix

alignment errors and make your photos level with the **straighten** tool. Use the **crop** tool to get rid of any extraneous subject matter near the edges that detracts from the shot or to zoom in slightly and give the photo more power. Remember, you're in control; if cropping the image will make it better, then crop away!

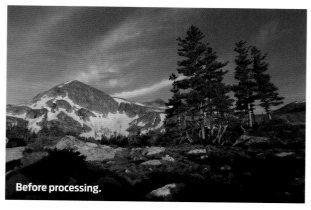
Before processing.

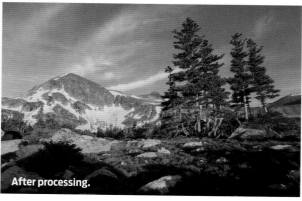
After processing.

Chapter Eight
Ten Essential Tips for Better Photos

This final section contains a list of ten quick tips that will help you create better, more powerful images. Each technique has been covered earlier in this book, but they're worth repeating. Use them when you're struggling for inspiration.

While this is hardly a comprehensive list, these ten ideas should be part of any outdoor photographer's bag of tricks. As you practice and improve, you'll add more.

1. **Wait for the best light:** Even more than compelling subject matter and decisive moments, the cornerstone of great photography is light. Capture your scenes under the warm hues of magic hour and you'll elevate the quality of anything you shoot.

2. **Keep it simple:** The viewfinder is your canvas, and everything that goes into it should be there for a reason. Each element should sit comfortably within your frame and play a part in describing the story, subject, location, or mood of your scene and, in turn, relate to the other elements in your frame. Don't try and show too much, or you'll kill the shot. Exclude any subject matter that detracts from the overall impact of the image. Give your viewer the bare essentials. Tell the story with as few words or brushstrokes as possible, and don't try to include too many subplots in your photograph.

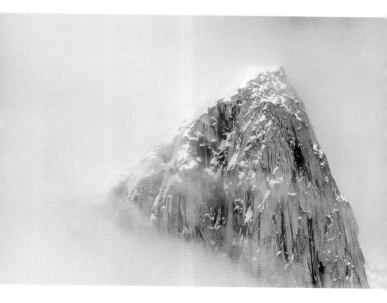

3. **Tell a story:** A photograph is a lot like a short story. With both, you have limited time in which to connect with your audience before leaving them with a strong memory of the experience. You do this by drawing your viewers in and leading them on a journey through the frame with a compelling narrative.

4. **Change your vantage point:** Getting your camera away from eye level will add interest to your compositions. Stand on top of something. Crouch down. Hold your camera

very close to the ground. Use a self-timer. Use specialized gear or creative ingenuity to put the camera into an out-of-the-way position. The possibilities are endless and are only limited by your imagination and equipment.

5. **Shoot in bad weather:** Dramatic weather makes for dramatic imagery, especially when it comes to adventure photography. Shoot in extreme, unpleasant, or otherwise misbehaving weather conditions, and you'll evoke a strong response from your viewers. Don't put your camera away just because the sun disappears.

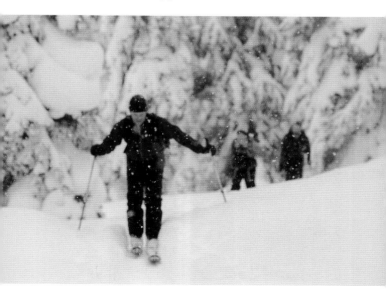

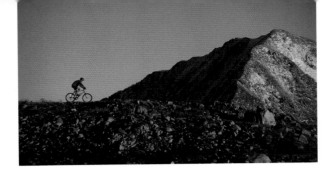

6. **Use bold color:** Our eyes are drawn to bold colors, specifically those in the "warm" and "hot" end of the spectrum. Accentuate colors like red, yellow, and orange in your frame, and you'll inherently pull your viewer's eye into the photo. Even a spot of red or yellow can have a strong impact on the power of your composition.

7. **Abbreviate your subject:** In photography, less is more. By showing only part of a subject, you force your viewers to engage their

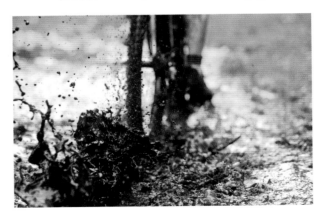

brains and imagine the parts that are missing. For this to work, you need to crop in a natural way; otherwise it will just look like a poorly executed framing. Also, don't hide a critically important element of the scene. The parts you show need to be strong enough to carry the entire image.

8. **Get closer:** Move in tight and focus on the details. Zoom in. Give your viewers an intimate look at the world and show them something that they've probably *seen* before, but might not have *noticed*. Get your viewers right into the middle of the action and let them think that they're about to trip over your subject! I guarantee that you'll take their breath away.

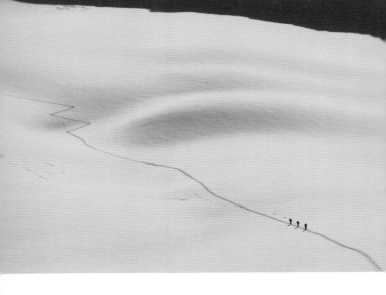

9. **Zoom out:** Okay, enough of the close stuff; now zoom out and give your viewer the whole scene. Show the dramatic expanse of the natural world and tell the story of how your subjects relate to their surroundings. Make your photo as much about *where* as *what,* and let your viewers imagine actually being there in that beautiful or rugged setting.

10. **Go somewhere new:** More than any single technique or piece of gear, the main ingredient to good photography is getting outside with your camera. Bottom line, if you're not out in the world, you'll never get the shot. You'll never get any shot.

To make great images, you must immerse yourself in places that ignite your passions and spark your visual senses. In the end, this is more important than technique or equipment. As much as you may obsess about cameras and lenses, a plane ticket, a road trip, or an afternoon spent exploring a new trail will do more for your photography than any piece of gear.

If you need a creative boost, get yourself out of the house and go somewhere, anywhere. Take a walk. Go for a run. Play outside. Get lost. Discover. Travel. Be. Live. Above all, have fun.

About the Author

Dan Bailey is a professional outdoor, adventure, and travel photographer based in Anchorage, Alaska. His work has been published by clients such as Fujifilm, *Outside* magazine, *Climbing*, *Rock & Ice*, Coleman, Discovery Channel Publications, National Geographic Adventure, The North Face, Marmot, and Patagonia. He has written articles for *Digital Photo Pro*, *Photo .net*, and *Outdoor Photographer*. Visit his website at: danbaileyphoto.com.